IMAGES
of America

OREM

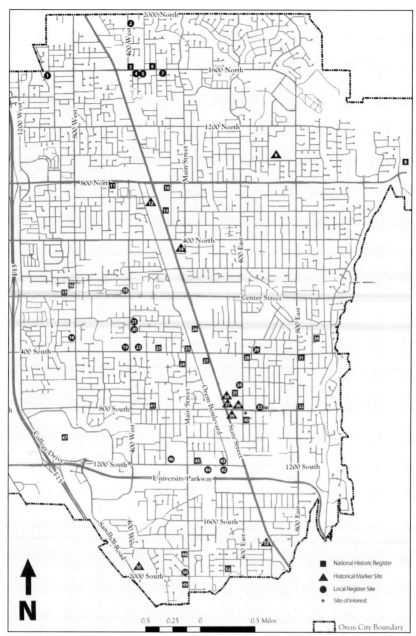

This map depicts the present boundaries of Orem, Utah, and the location of historical sites and places of interest. A detailed pamphlet with information on each of these sites is available from the City of Orem and is listed in the bibliography. (Courtesy of Orem Historic Preservation Advisory Commission.)

ON THE COVER: Three early Orem pioneers, M. Dover Hunt, Walter R. Holdaway, and E. Carlisle, typify Orem's agricultural heritage during the first half of the 20th century. Beginning with grazing, moving to berries, and finally to fruit orchards, by the 1930s, Orem produced more fruit than any other Utah community. (Courtesy of Orem Heritage Museum, SCERA.)

IMAGES
of America

OREM

Jay H. Buckley, Chase Arnold,
and the Orem Public Library

ARCADIA
PUBLISHING

Published by Arcadia Publishing
Charleston, South Carolina

Printed in the United States of America

Library of Congress Control Number: 2009935204

For all general information contact Arcadia Publishing at:
Telephone 843-853-2070
Fax 843-853-0044
E-mail sales@arcadiapublishing.com
For customer service and orders:
Toll-Free 1-888-313-2665

Visit us on the Internet at www.arcadiapublishing.com

This book is dedicated to Orem residents—past, present, and future—who devote their lives to encourage education, develop industry, support civic and cultural endeavors, promote wholesome recreation, and serve one another.

CONTENTS

ACKNOWLEDGMENTS

A local history such as this requires the assistance of many people. Special recognition goes to two of my outstanding undergraduate students at Brigham Young University—Nathanael Paynter and Chase Arnold. Nate helped me track down some photographs early on, and Chase came on board to track down leads, help acquire photographs, and draft some of the captions, earning him recognition as a coauthor. I also thank the Orem Heritage Museum and Orem Public Library for their assistance.

I extend my gratitude to a number of individuals and institutions for their support of this endeavor. I was assisted at the George Sutherland Archives at Utah Valley University by Amber Frampton, Michael Freeman, and especially Catherine McIntyre; at the Orem Public Library by Louise Wallace; at the Orem Heritage Museum by David Lee, Brent Farley and Linda Rowland; at the L. Tom Perry Special Collections, Harold B. Lee Library, Brigham Young University by Russell Taylor, Thomas Wells, and John Murphy; at the Utah Valley Chamber of Commerce by Steve Densley; at the Church History Library of the Church of Jesus Christ of Latter-day Saints by Ronald Read; at the Western History Collection at the Denver Public Library by James Kroll; and at the Utah State Historical Society by Gregory Walz.

I am grateful for the encouragement of City of Orem employees Tamara Beardall, Jason Bench, and Sarah Wilcox, as well as members of the Orem Historic Preservation Commission including Jenni Prince-Mahoney and Cory Jensen. Notable individuals who assisted with locating images or offered advice include Sterling Bylund, Kenneth Cannon II, Barbara Davies, Gary Daynes, Chris Dunker, Diana Turnbow, Dan Wright, and many others. Particular thanks is extended to Lon and Reva Bowen and Clyde and Helen Weeks, two local couples whose research, writing, and enthusiasm for Orem's history have done much to help shape and preserve it. I am indebted to Clyde E. Weeks Jr. for his careful reading of, and recommendations for, the manuscript. Any errors that remain are my own.

I also thank Jared Jackson, Kristie Kelly, and Hannah Carney of Arcadia Publishing for their interest and support in publishing and preserving local history.

—Jay H. Buckley

INTRODUCTION

Nestled in Utah Valley between the eastern shore of Utah Lake and the foothills of Mount Timpanogos, Orem, Utah, rests upon Lake Bonneville's ancient shoreline in the Great Basin. In September 1776, Franciscan friars Silvestre Vélez de Escalante and Francisco Atanasio Domínguez arrived in Utah Valley and recorded descriptions of the valley as possessing a comfortable climate, abundant water, grass, timber, and rich soil. Their journals described the Timpanogos Utes as a friendly people who called the valley home, and they reported that Timpanogos Lake (Utah Lake) and Timpanogos River (Provo River) were teeming with trout and waterfowl.

Spanish trading expeditions visited the Utes to trade, and by the 1820s French-Canadian and American mountain men such as Etienne Provost, Jedediah Smith, Jim Bridger, and others trapped beaver along the streams flowing out of the Wasatch Mountains into the lake. In 1849, Mormon pioneers (members of the Church of Jesus Christ of Latter-day Saints) moved south from Salt Lake City to construct Fort Utah near the river's mouth. A few years later, the town relocated some 2 miles to the east. Provo, Pleasant Grove, and other areas of the valley with streams grew over the next few decades, and settlers displaced and dispossessed the Utes, renaming Utah Lake and the Provo River in the process. The expanding population overfished the river, dammed the lake, and turned to farming and ranching to provide their sustenance.

Over the years, the pioneer road crossing the benchland between Provo and Pleasant Grove became a part of the nationwide system of highways and was designated U.S. Highway 91, fulfilling Brigham Young's prophecy of the area: "Some day all this sagebrush will disappear, water will be taken out of the Provo River in canals for irrigation, and this land will become a beautiful garden spot where many kinds of delicious fruit and vegetables will be grown, beautiful homes will be erected, and Provo and Pleasant Grove will be as one solid city."

It took some time for Young's vision to come to fruition. By 1861, several pioneers ascended the Provo Bench. Some of them used the area to graze their livestock, while others uprooted the sagebrush, dug irrigation ditches, and planted vegetable crops and fruit orchards. Yet most still spent the winters living in Provo. The Provo Bench Canal and Irrigation Company was the first of many water companies to divert Provo River water onto the Provo Bench. After the federal land office opened in Salt Lake City in 1869, settlers could file homestead claims for land they were improving. Thomas and Mary Ann Benson Cordner are credited with being the first year-round residents in 1877.

As wells were dug and canals were completed, additional residents arrived. By 1900, the community numbered 692 residents. In an effort to attract business and to catch the attention of Walter C. Orem, the president of the Salt Lake and Utah Electric Inter-urban Railroad, a vote was held on whether to join ranks with Provo or incorporate as the town of Orem. The latter proposition carried by two-thirds of the vote. After 1919, trainloads of fruit bearing the Orem name traveled on Walter Orem's railroad and earned the area the nickname of Garden City of Utah.

Schools such as Spencer, Sharon, and Lincoln quickly took root along State Street. In 1919, the town of Orem was incorporated with 1,664 residents. Not until 19 years later, however, did the Orem Board of Trustees have a town hall in which to conduct business. Orem members of the Church of Jesus Christ of Latter-day Saints (LDS) erected their first meetinghouse in 1898. Electricity from Lucien and Paul Nunn's Olmstead Power Plant arrived in 1912. A town marshal was appointed in 1923, and the *Voice of Sharon* newspaper began bimonthly publication in 1929.

The Great Depression sparked interest and support for cultural and recreational pursuits. The LDS Sharon Stake president Arthur Watkins and LDS seminary principal Victor Anderson spearheaded the creation of Sharon's Cooperative Educational and Recreational Association (SCERA) in 1933. By 1941, they had collected enough revenue to construct a public swimming pool and a movie auditorium. During World War II, they assisted with war bond drives.

The 1940s witnessed a population boom with the annexation of the Grandview, Carterville, Lakeview, and Vineyard communities and the construction of the Geneva Steel Plant to aid the war effort. Many mill workers were housed in some 200 trailer homes located east of Orem City Hall. In 1943, Erval and Christa Mix Christensen built 65 single-family homes in a residential subdivision on land purchased from the Steele family. Named Christeele Acres, the collection of one-story brick cottages—between State Street and 500 East, and 900 South and 1010 South—represents one of the oldest subdivisions and is a National Register historic district. The influx brought additional municipal needs such as sewage treatment, culinary water, landfills, police and fire services, and a post office. In 1938, the James Stratton home was acquired for a town hall, post office, and public library at the intersection of Center Street and State Street.

In 1949, the four-lane State Street was paved, and some of the 8,338 residents raced their cars along the 5-mile "Velvet Strip." Drive-ins, cafes, and businesses jockeyed for prime locations along the thoroughfare. In 1970, a new Orem city center and library were dedicated, as the orchards surrounding the area gradually succumbed to commercial and residential growth. The construction of the University Mall in 1972 on the corner of State Street and 1200 South (University Parkway) sparked additional commercial and residential growth, as did the construction of a college campus (now Utah Valley University) in 1975. By 1980, Orem's population was nearing 50,000.

Located 45 miles south of Salt Lake City in Utah County and situated in the north central part of the state, Orem shares much of its history with its sister city, Provo. The Orem/Provo metro area is now home to a quarter of a million people, with Orem's population approximately 100,000. Orem comprises 18.5 square miles of land and represents the sixth-largest city in Utah. In the early 20th century, the Provo/Orem area was known as the "Garden City of Utah." In the 21st century, Orem is touted as "Family City, USA."

Orem is bordered by Lindon on the north, Vineyard on the west, and Provo on the south and east. The city is located in the Alpine School District and is currently home to 3 high schools, 3 junior high schools, and 16 elementary schools. Utah Valley University and Stevens-Henager College are also located in Orem. Brigham Young University, one of the largest private universities in the United States, is located in neighboring Provo. The Orem Owlz of the minor league baseball Pioneer League, the Utah Flash of the National Basketball Association's Development League, and the Utah Valley Thunder of the American Indoor Football Association all play their home games at Utah Valley University. Orem is popular for its Summerfest celebration and parade, which take place the second week in June. Orem hosts the annual Timpanogos Storytelling Festival and, based on its size, has more park acreage than any other city in Utah. It is a great place to live and rear a family.

One

PROVO BENCH PIONEERS

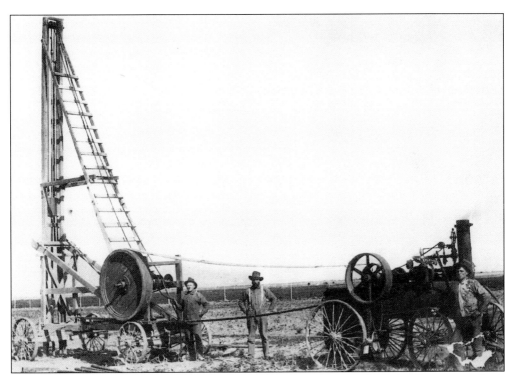

As pioneers moved into Utah Valley, there was little incentive to settle in the Orem area, which was then called the Provo Bench. The sagebrush-covered ground offered some grazing potential but no streams graced the Bench, so the majority of settlers moved south to Provo. Bringing life-giving water meant either diverting it from springs or streams up Provo Canyon or digging wells. Victor Andersen, Marion Holdaway, and an unnamed worker dug this well on the Holdaway homestead around 1900. (Courtesy of Town of Vineyard.)

These early images of Utah Valley offer vistas looking south and east. Pictured are the Wasatch Mountains and Provo Bench around 1910, when Utah Valley still had large tracts of unsettled and uncultivated land. (Courtesy of Utah State Historical Society.)

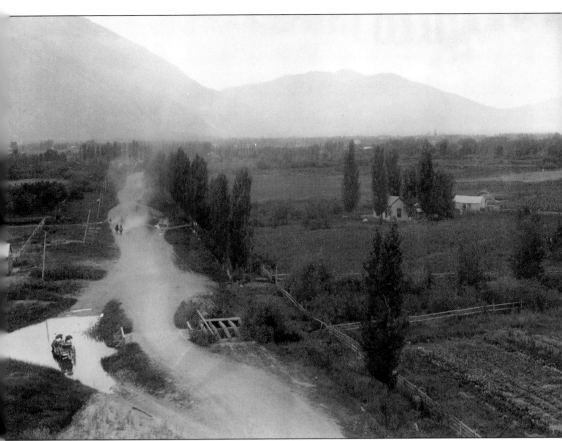

Mormon leader and territorial governor Brigham Young ordered a territorial dirt road constructed to connect northern and southern Utah. This territorial road ran straight across the Provo Bench. This William Henry Jackson photograph of the Provo Valley in the 1870s shows a horse-drawn buggy stopped to let the horses drink while two men ride horseback down the road. In 1926, U.S. Highway 89 was commissioned to run from Yellowstone National Park to the Mexican border and followed the territorial road through much of Utah. This road (State Street) served as Orem's main thoroughfare as businesses began lining its edges. (Courtesy of Western History Collection, Denver Public Library.)

Irish immigrants Thomas and Mary Ann Cordner are credited as the first settlers on Provo Bench and lived in this "dug out." Constructed around 1877 at about 1200 East 200 South in Orem, it afforded a warm home in winter and a cool one in the summertime. Most farmers who utilized the Bench for farming or grazing chose to live in Provo, especially during the winter, returning in the spring to plant. The Cordners led the vanguard to call Provo Bench home. They later built one of the first homes (located at 3 South and 1000 East). Their son Alexander Cordner was the first baby born in the area, on March 17, 1879. (Courtesy of Lon Bowen.)

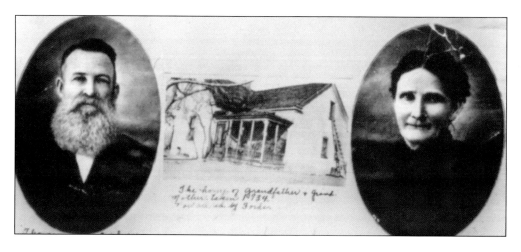

Jesse Knight–a local mining magnate, industrialist, and philanthropist–purchased 500 acres near Orem's present city center and donated it to Brigham Young Academy (Brigham Young University). To increase the land's worth, the university organized a volunteer workday to clear away the sagebrush plants that covered the area and stack them into piles, which people could purchase for fuel. Spurred on by music from the BYU band, in one day these "sagerooters" cleared the entire acreage, which was later leased or sold in parcels to finance various campus projects. Knight and his family donated tens of thousands of dollars to the university before his death on March 14, 1921. His contributions of land, irrigation bonds, and money ensured the early financial survival of BYU, and several buildings on campus were named to honor the Knight family. (Courtesy of L. Tom Perry Special Collections, Brigham Young University.)

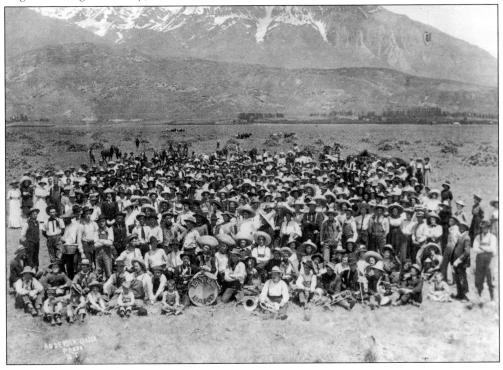

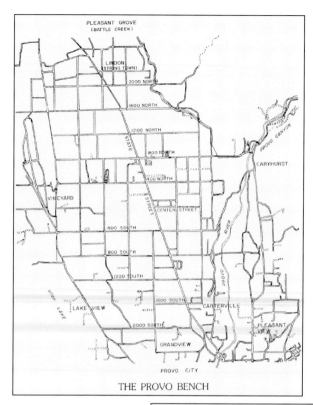

THE PROVO BENCH

Some of the earliest residents on the Provo Bench included Thomas Barrett, Sam Baxter, Alfred Billings, Thomas Cordner, Joseph Evans, Samuel Hadfield, Andrew Johnson, August Johnson, Charles Johnson, J. King, M. Knight, Newell Knight, James Loveless, Amasa Mecham, Elliott Newell, David Park, John Park, Thomas Patten, Samuel Skinner, James Stratton, and Peter Wentz. (Courtesy of Orem Public Library.)

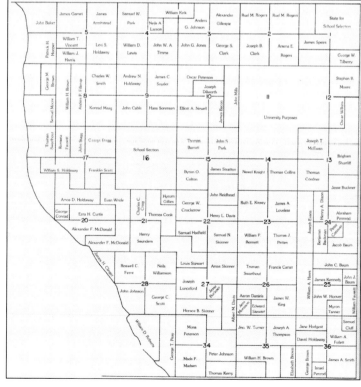

Stephen I. Bunnell Jr. built his adobe home (pictured below) in 1892, four years before Utah achieved statehood. The house originally had five rooms, including a living room, kitchen, and three bedrooms. Pictured here in 1901, Bunnell planted 100 trees to keep his home cooler in the summer and his wife, Mary Elizabeth Gammon, planted flower gardens that she watered from a retention pond, which doubled as a family swimming pool for their nine children. Bunnell served on an LDS church mission to California and, upon his return, represented Orem's Johnny Appleseed, introducing red apples to the Provo Bench. (Courtesy of Lon Bowen.)

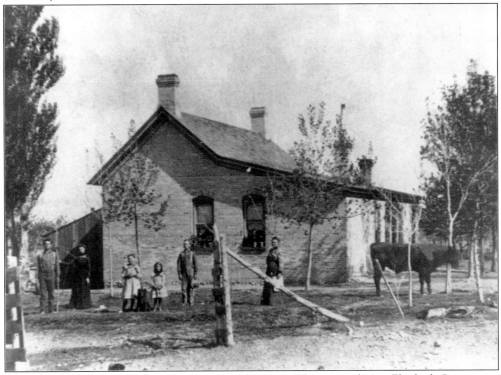

Members of the Bunnell family—Stephen, Huldah, Emma, Thomas, and Mary Elizabeth Gammon—stand in front of the last remnant of a 19th-century abode in Orem. The Bunnell pioneer home has been restored and is located on the Utah Valley University campus. (Courtesy of Clyde and Helen Weeks.)

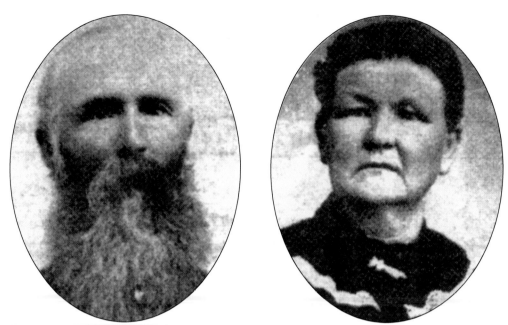

Thomas Barrett Sr. married Sarah Stott Bladon, and their family joined the LDS church in 1851. They emigrated from England to America in 1873 with their five children. Barrett filed a homestead claim for 160 acres of Section 15 of the Orem Township on April 8, 1878. Their home and property (approximately 63 North and 400 West) contained a house, barn, granary, and sheds as well as the only sorghum mill in Utah County at the time. They also raised sugar cane and made their own molasses. (Courtesy of Lon and Reva Bowen.)

John H. Carter Sr. acquired 85 acres in the 1870s from Benjamin Bachman. Carterville Road, which skirted the Provo Bench and extended all the way to Provo Canyon, was named after Carter and his son John H. Carter Jr., who, with his polygamous wives Elizabeth and Sophia (pictured), owned several homes and a blacksmith shop. (Courtesy of Lon Bowen.)

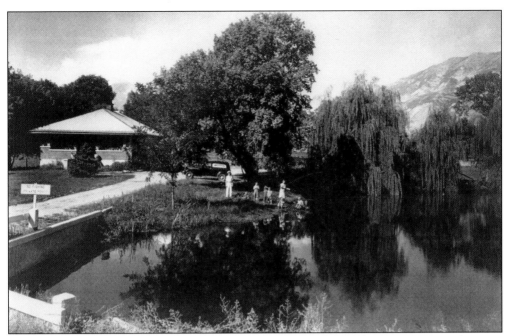

The William Albert and Grace Nuttall home in Grandview during the 1930s contained mature trees, beautiful flower gardens, and an irrigation pond. The Nuttall Jersey Farm featured a prized herd of registered Jerseys, representing one of the most successful diary operations in the state. They produced high quality milk and cream that was distributed throughout the valley. Their dairy cattle won prizes at the Utah County and Utah State fairs, and one heifer even traveled to the 1939 Treasure Island World's Fair in California. At the 1940 Utah State Fair, the Nuttals won first prizes for best dairy herd, senior sire, bull calf, graded herd, and two-year-old heifer. These combined awards earned the Nuttall's the honor of "Premier Breeder and Exhibitor of Utah." (Courtesy of John and Margaret Nicol.)

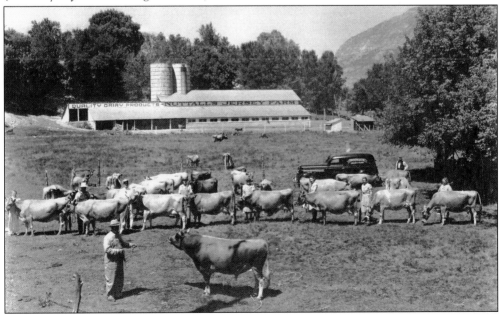

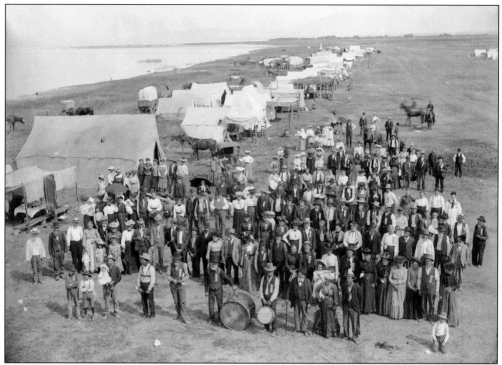

A reunion of Indian War veterans was held on August 14, 1903, at Utah Lake to remember the 121 men who lost their lives fighting in the Indian Wars, from the Walker War of the 1850s to the Black Hawk War of 1868. (Courtesy of L. Tom Perry Special Collections, Brigham Young University.)

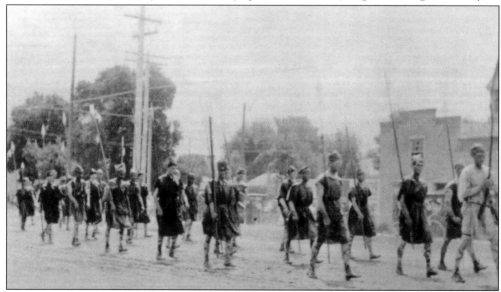

This picture was taken at the Fourth of July Parade in 1904 on Church Street (800 South) in Orem. The young men were recreating a scene from the Book of Mormon wherein Helaman's band of stripling warriors helped protect and defend the freedom and liberty of the Nephites. Their leader, Helaman, was portrayed by Artemus Holman Sr. who was selected because of his great stature since he stood at 6 feet, 6 inches tall. (Courtesy of Lon Bowen.)

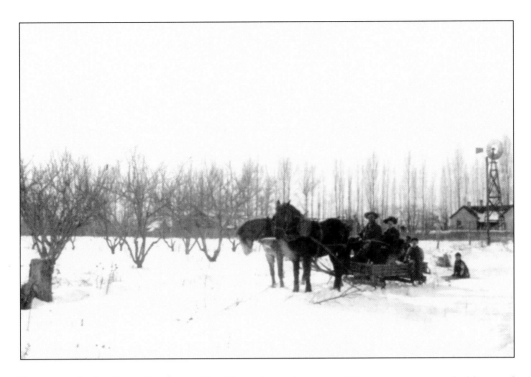

Even though the Provo Bench usually did not have deep snowfalls, everyone went sledding and sleigh riding in the winter. Since the snow on the roads would not always last long underneath the numerous wagons and sleds, residents often went "off-road" through the fields. Horses even proved helpful to pull broken-down automobiles needing repair. A team of horses hitched up to the car could tow it like a wagon. These images capture Orem in a moment of transition from agriculture to industry during the World War I era, as workers near Olmstead Power plant go for a car ride via horsepower. (Courtesy of Lon Bowen and Greta Bandley.)

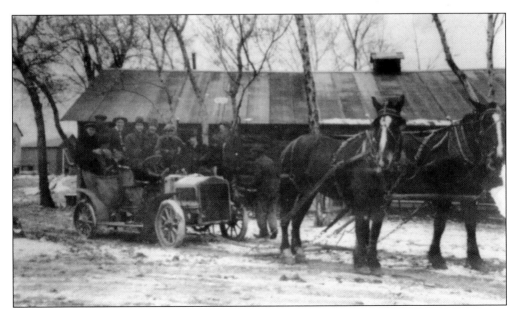

While the McKinsey-Otto Poulson adobe home was utilized as the first Orem school in 1880, the first school built was Spencer Elementary. On February 7, 1883, the Provo Bench School District Number 18 purchased three acres of land from William Roberts on the southeast corner of 800 South and State Street for $48 to construct the school. Named after the great English philosopher Herbert Spencer, the school consisted of a 20-by-30-foot log cabin built in 1883 with a large woodburning stove in the center. Long benches on either side accommodated twelve students. In 1890, Edward Partridge added a two-room brick addition to serve as a large classroom and a hall. By 1912, the log cabin had been removed and the brick structure updated and enlarged into a two-story, eight-room building. Spencer Elementary was demolished in 1992. (Courtesy of Orem Heritage Museum, SCERA.)

Samuel Bunnell was one of the first teachers who taught at Spencer Elementary. Other educators including Henry Aird, Tay and Bora Chase, Mr. Chalmer, Della Green, William Henry, Rilla Hiatt, Ada John, Frank McGraw, W. K. Nelson, Minnie Noble, Sadie Talmage Patten, Florence Rogers, Hanna Belle Smith, Gertrude Thurman, Ray and Lillie Wentz. (Courtesy of Clyde E. Weeks Jr.)

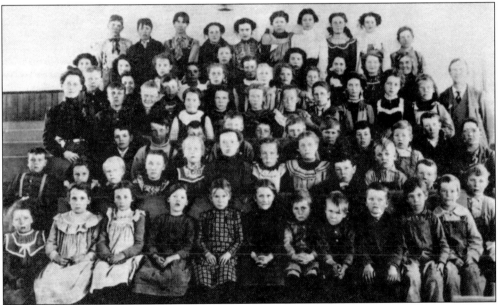

Spencer School students and teachers are pictured in this 1902 photograph. From left to right are (first row) Rachel Draper, Elsie Skinner, Emma McEwan, Rachel Kartchner, Edith Woffinden, Louie Farley, Ernest Woffinden, Vance Clinger, Phillip Skinner, Roy Park, Oscar Terry; (second row) Burdell Bunnel, Bertha Nuttal, Verena Crandall, Ellen Lunceford, Mamie Crandall, Janie Jaggers, Mary Ann Lunceford, Nancy Carter, Henry Ive, Rowe Clinger, Leo Hills; (third row) Della L. Green (teacher), George Loveless, Irving Skinner, unidentified, Roy Cordner, unidentified, Fred Knight, Ray Park, Ross Bunnell, Morley Prestwich, Bill York, Leslie Farley; (fourth row) Art Clinger, Willard Bishop, Judd Carter, Roselee Terry, Etta Knight, Amanda Bigelow, Ethel Handley, Jennie Draper, Vera Salisbury, Hazel Loveless, Grace Nelson, Ray V. Wentz (teacher and principal); (fifth row) Horace Prestwich, Theria McEwan, Malissa Danniels, Ada Carter, Lois Downs, Vinnie Jaggers, Estella Pace, Josie Patten, Edith Prestwich, Amy Mecham, Laura Kartchner, Florence Pace, Ethel Mecham, Fanny Terry, Lavina Selman, Ella Hills; (sixth row) Leo Knight, Jim Clark, Larry Salisbury, Annie Loveless, Willa Williams, Carrie Draper, Adeline Farley, Alice Mann, Jennie McEwan, and John Hills. (Courtesy of Daughters of the Utah Pioneers.)

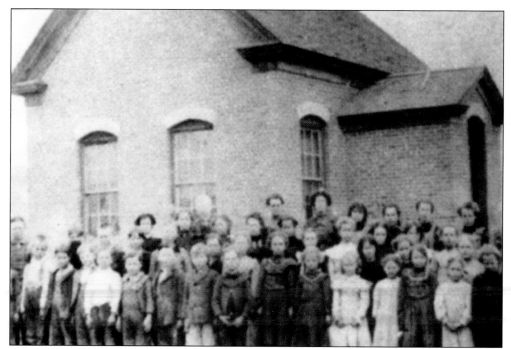

The original Sharon School, located at 300 North and State Street, was the second school built in Orem. Built in 1894 and named after Sharon, Vermont (the birthplace of Joseph Smith, the founder of the LDS Church), this larger brick structure replaced it in 1909. The school held classes until the end of the 1954–1955 school year, after which it was demolished. (Courtesy of Orem Heritage Museum, SCERA.)

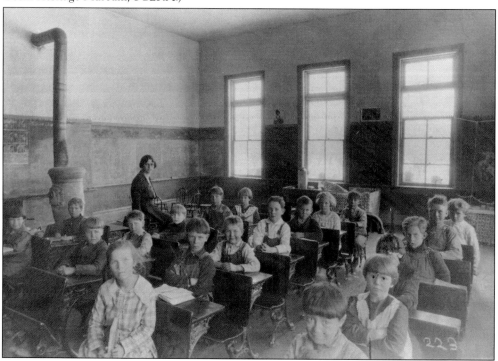

The Timpanogos Ward of The Church of Jesus Christ of Latter-day Saints was organized on November 8, 1885. Thomas Jefferson Patten Sr., nephew of Apostle David W. Patten, donated the land for the first church building in Orem. Before its completion, the Timpanogos Drama Club presented plays, and the proceeds from the productions went to help finance the chapel. Completed in 1898, the building served many religious, social, and civic functions and was located adjacent to the Spencer School on Church Street. Remodeled several times, the church still serves as an LDS meetinghouse at 450 East and 800 South. (Courtesy of Jay H. Buckley.)

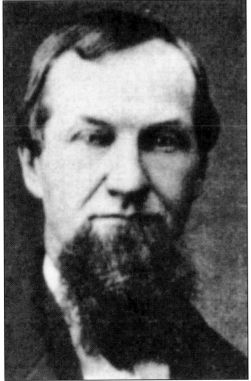

Called and sustained as the bishop of the Timpanogos Ward in 1885, Bishop Peter M. Wentz served his congregation from 1885 to 1903 when he was replaced by Otis L. Terry Jr. Wentz and his wife, Minerva Boren Call, raised a family on the corner of 800 East and 800 South and their son Ray V. Wentz was the first LDS missionary called from the Timpanogos Ward, serving from 1895 to 1898. (Courtesy of Lon Bowen.)

The Hooper Ditch in Carterville offered a suitable location to perform baptisms for the Timpanogos-Orem 11th Ward. Members of the Timpanogos Ward, like other Utahns, celebrated the 24th of July each year. Along with remembering their national heritage on the Fourth of July, Orem's residents commemorated the legacy of their ancestors. Many of Orem's early residents descended from Mormon pioneers who had crossed the plains to escape religious persecution in the East. On the 24th of July, they commemorated the arrival of the 1849 Saints into the Salt Lake Valley and called the local holiday "Pioneer Day." This 1909 celebration in Orem featured its participants in full pioneer regalia. The Timpanogos Ward Chapel is in the background. (Courtesy of Orem Heritage Museum, SCERA.)

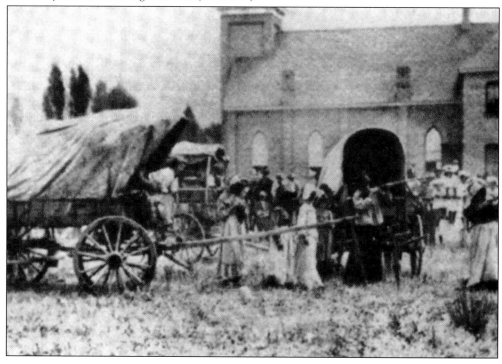

Two

THIS IS THE PLACE
... FOR FRUIT

Orem's rural population formed canal co-operatives to supply water to the Provo Bench. Once the canals were completed, farmers moved onto the Bench in a scattered farm or "Gentile Fashion," with their homes typically facing the roads and their farms and orchards extending to the rear. This settlement pattern was different than in typical Mormon communities, wherein a town grid system was plotted, and people's farms were typically outside the town. Orem's vast orchards and extensive vegetable gardens produced tons of fresh peaches, apples, tomatoes, and other crops to consume locally, process in canneries, or ship out on the Orem Line. The Orem area became well known as the Garden City of Utah. Miss Orem 1966 Shauna Burgon poses by an apple tree, promoting Orem's orchards. (Courtesy of Orem Public Library.)

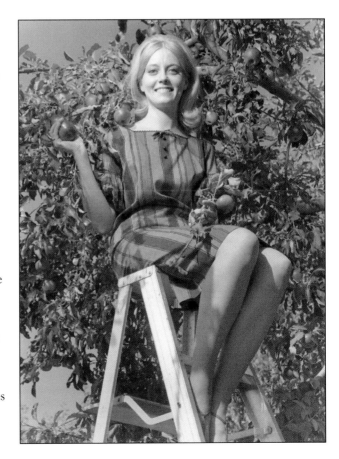

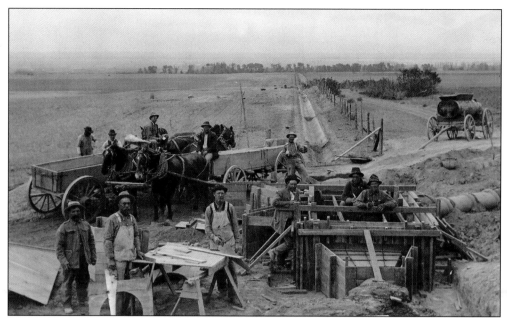

Since Mormon pioneers had arrived in Utah Valley, the Provo Bench seemed like a perfect place to live, yet it lacked the essential ingredient—water. Difficulty in drilling wells and lack of streams prompted enterprising residents to look for other ways to irrigate the land. Local farmers began digging the Provo Bench Canal in 1862. When finished in 1864, farmers started planting but they did not build homes on the Bench. The canal was repeatedly redone to improve its construction and utility. As other springs and sources became available, additional canals like the Orem-Payson Canal were completed. During the Depression, the Works Progress Administration provided funds to help Orem line its irrigation canals with concrete. (Above, courtesy of LDS Church History Library; below, courtesy of Utah State Historical Society.)

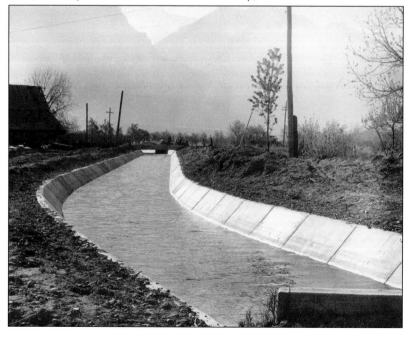

Water use for farming. When the canal was finished, shareholders filed for certain specified amounts of irrigation water for beneficial use. Water masters made sure no one took more than their allocation. Sometimes a police officer, like J. Reed Bergener, served as water master. Usually local LDS church leaders and the water boards handled disputes among their members. (Courtesy of Orem Public Library)

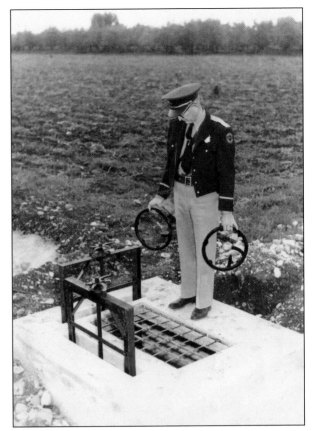

Orem farmers had a great product, but sometimes marketing proved problematic. When they had more produce than the local market could handle, many farmers took their fruit to the mining camps in Park City nearly 40 miles away, where farmers found paying customers eager to get their hands on an Orem-grown peach or apple. Hosea Davis and Joe Hill sit in the driver's seat of this fruit-filled wagon. (Courtesy of Wanda Davis Thatcher and Orem Public Library.)

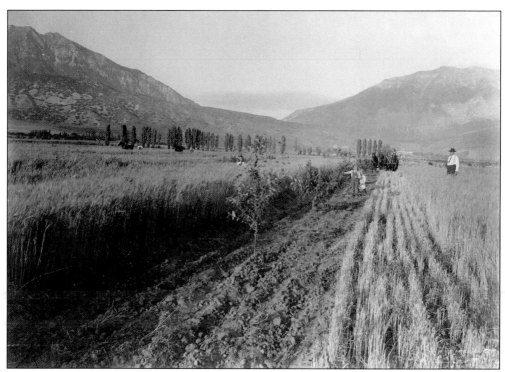

As Orem's water supply system improved, farmers' crops flourished. The ground proved fertile for nearly any crop, once irrigation water was available. When the settlers first came into Utah Valley they hoped that the rocky soil, combined with warm days and cool nights, would allow fruit trees to flourish. Yet, they also needed to grow staple crops for themselves and their animals to survive. As the Bench's orchards expanded, wheat, corn, hay, and other crops continued to be planted, tended, and harvested. (Above, courtesy of Utah State Historical Society; below, courtesy of L. Tom Perry Special Collections, Brigham Young University.)

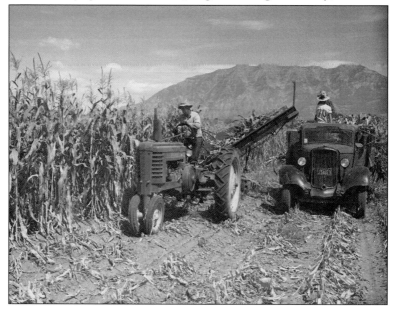

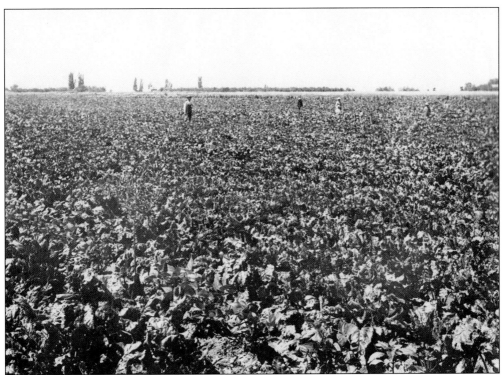

Orem farmers also produced wonderful vegetable crops. Tomatoes, sugar beets, and beans were all grown and harvested by hand. (Courtesy of Utah State Historical Society.)

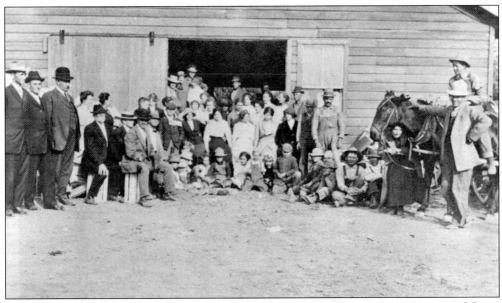

Apple pickers pose after a successful harvest. (Photograph by Vera Mecham; courtesy of Orem Heritage Museum, SCERA.)

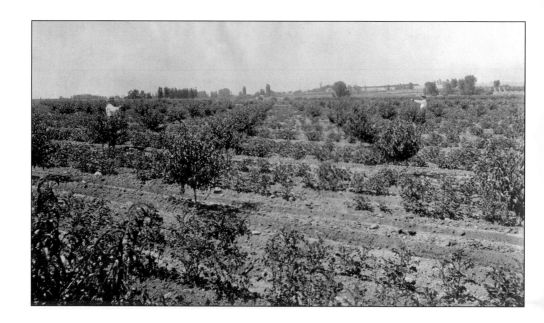

In 1885, Newell Knight Sr. and Newel Knight Jr. planted the first peach orchard of considerable size on the Bench. Their investment proved successful and other farmers began planting peaches soon thereafter. Building upon the Knights' success, other farmers experimented with growing pears to see how other fruits would fare in the soil and at the market place. It was not long before they realized the potential that fruit held for their future. Peach orchards, in particular, proliferated, as attested by these workers canning the harvest. (Above, courtesy of Utah State Historical Society; below, courtesy of Orem Public Library.)

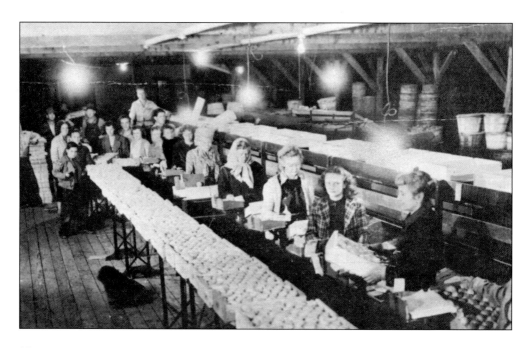

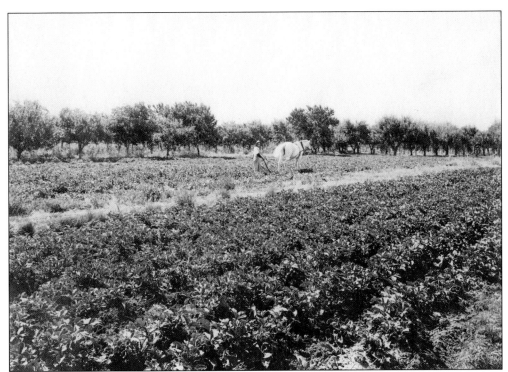

When fruit started to flourish on the Bench, strawberries offered one of the fastest growing crops and sold for 25¢ a quart. Unlike peaches or pears, which required well-tended trees that could take years to mature, strawberries could be planted and produce the next season. During strawberry harvest time, neighborhood kids hired on. With plants low to the ground and the fruit easily picked, people of all ages could harvest. A man and his plow work an Orem patch in the early 1900s, while the second photograph shows workers harvesting strawberries with Mount Timpanogos in the background around 1936. (Courtesy of Utah State Historical Society.)

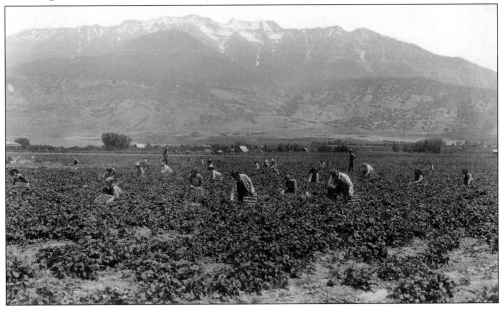

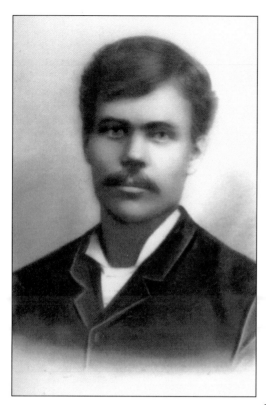

Fields and orchards were not simply a family's livelihood. They represented a common dream, a united effort, and a family's legacy to the next generation. From planting to harvest, the farm united the family. James Stratton was among the first settlers to arrive, and his son John Henry Stratton (pictured here with his wife, Emma Evans) moved to Orem in 1887. For the Strattons, producing high quality fruit became a family business. The Stratton family has been producing fruit for over a century and continues to operate one of the few remaining orchards in Orem. (Courtesy of Lon and Reva Bowen.)

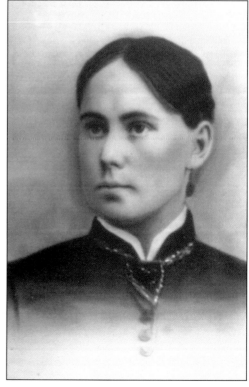

Martin B. Walker set out some crates filled with fruit by the side of the road to sell to passers-by in 1913. Word spread, and people returned the next day. Over the next few years, Walker built a roadside fruit stand he named "This is the Place" to display his produce. Orchards gave geographical and economic substance to Orem. Growing fruit was a family affair and Walker eventually passed the business on to his children. Some residents still grow fruit for their livelihood, but economic realities often cause them to sell their orchards for residential or commercial development. (Photographs by Barney Walker, courtesy of Orem Heritage Museum, SCERA.)

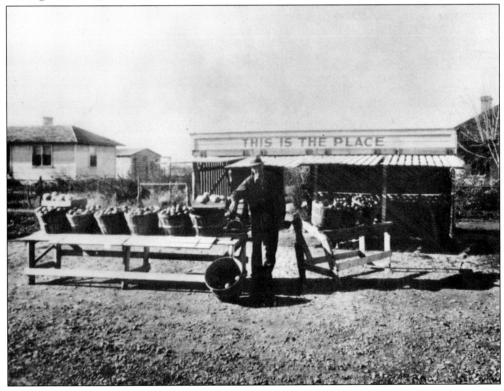

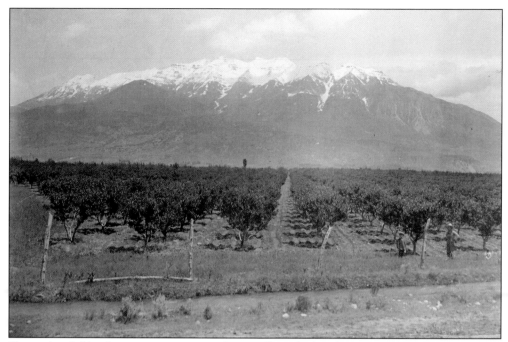

Vast orchards like this one containing apple trees flourished within view of Mount Timpanogos. Orem's fruit market was so successful because of the collective efforts of families. A group of women package apples to be sold to Jack Phillips, the gentleman standing beside the crates. Pictured are, from left to right, William H. Homer, Jack Phillips, Mae Dyer, Vera Burr, Willa Pace, unidentified Dyer son, Mrs. Dyer, and Mr. Dyer. Assisting the process are Mrs. Dyer (the woman on the far right), her son (just behind her), her daughter (the young woman on the far left), and her husband (the gentleman standing in the back). Orem's farms helped keep families together, as they worked each day, side by side. (Above, courtesy of Utah State Historical Society; below, courtesy of Theresia Clayton Pyne and Orem Heritage Museum, SCERA.)

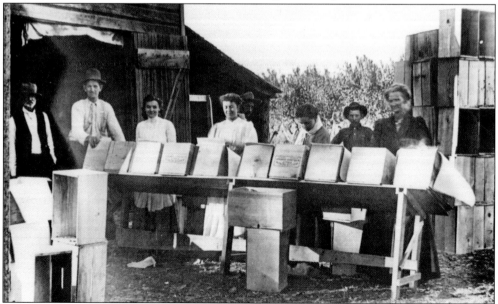

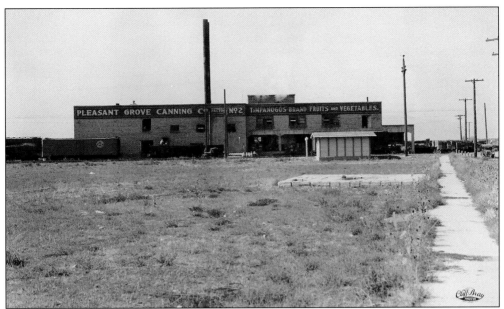

After the coming of the Salt Lake and Utah Railway, canning factories were constructed at or near Orem to facilitate canning and shipping the produce. The Pleasant Grove Canning Company, built in Orem in 1919, and the nearby Pacific Coast Cannery at the Provo Junction train stop, represented two of the 44 canning plants in Utah in the 1920s. With the Orem cannery so close, local farmers began growing tomatoes. As the cannery prospered, sugar beet slicer facilities were built nearby in Lakeview and Lindon, causing Orem's farmers to begin planting sugar beets. Each of these companies came to Orem because of the farmers' success, and indirectly began influencing them to grow different crops to increase their prosperity. (Courtesy of L. Tom Perry Special Collections, Brigham Young University.)

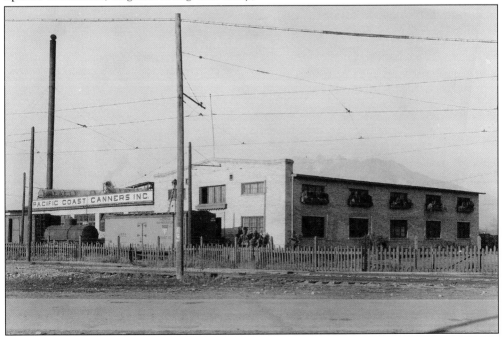

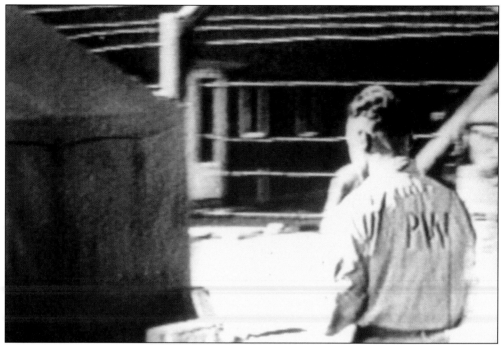

By World War II, Orem was full swing into the transition from farming to industry. Nevertheless, many orchards needed workers, especially since many of Orem's young men and women had enlisted in the military. The federal government built an internment camp in 1943 at the site of the present Canyon View Junior High and Orchard Elementary schools to house Japanese-Americans, uprooted from their homes along the West Coast. After the Japanese had been relocated to Topaz, Utah, the camp was turned into a prisoner of war camp and Italian and German prisoners were housed there. Orem's farmers visited the camp and received truckloads of prisoners who would work their fields and orchards for the day. Although an armed guard stayed with each group of prisoners for security, some of Orem's farmers were able to establish friendships with the prisoners. One family asked every prisoner to write them after the war. They received letters throughout the years and later traveled to Germany to visit their old field hands. (Courtesy of Lon Bowen and Hollis Scott.)

Three

THE POWER OF NUNN

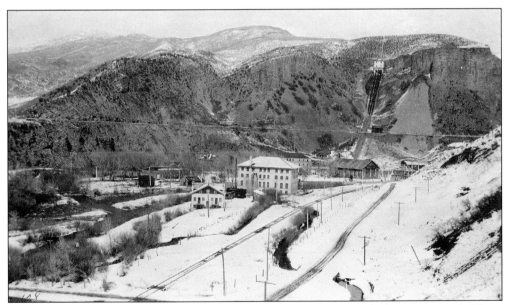

Barely five feet tall and weighing one hundred pounds, entrepreneur and educator Lucien L. Nunn was an industrial giant who electrified Utah when he expanded his Colorado-based Telluride Power Company into the Beehive State in the 1890s. Moving his corporate office and personal residence to Provo Canyon, first with Nunn's Station and then with the Olmstead Power Plant, Nunn supplied electricity to railways, mines, streetcars, and residential consumers throughout Utah. Orem and Provo were among the first western towns to be electrified with alternating current. (Courtesy of L. Tom Perry Special Collections, Brigham Young University.)

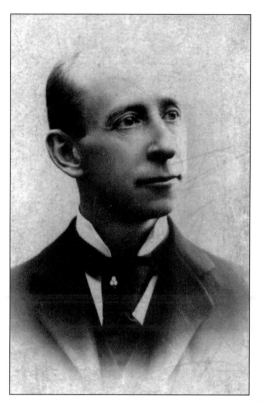

Born on a farm in Modena, Ohio, in the 1850s, Lucien (L. L.) and Paul Nunn became some of the earliest American entrepreneurs in electrical engineering. L. L. (pictured) studied at the University of Leipzig in Germany and received a law degree from Harvard. In the 1880s, L. L. operated the Gold King Mining Company in Ames, Colorado, which included gold and copper mining operations and an ore-processing mill. The mill was run on coal-generated steam power, but, as the price of coal began to rise to $50 a ton, he began searching for alternatives. (Courtesy of Orem Heritage Museum, SCERA.)

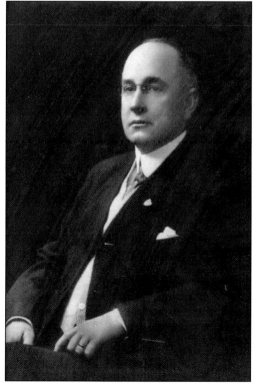

L. L. recruited his brother Paul (pictured), an engineer, and together they experimented with hydroelectric production generated from the energy of falling water. Together they tailored the harnessing and the use of an alternating electric current system first designed by Nikola Tesla, a Croatian engineer working for George Westinghouse. The Nunns' experiment was successful, so they founded the Telluride Power Company, which eventually serviced 20 cities throughout Idaho, Colorado, Utah, and Montana. (Courtesy of Orem Heritage Museum, SCERA.)

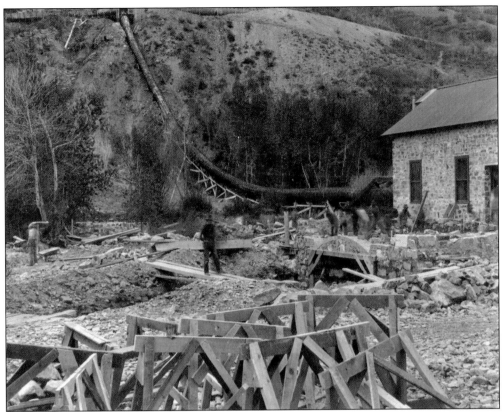

Following their initial success in Telluride, the Nunns sought to establish a new plant in the Wasatch region. They selected Provo Canyon as a suitable site and built Nunn's Station in 1895, 3 or 4 miles up the canyon. In Ames, they had succeeded in the first long-distance transmission of electricity, transmitting 3,000 volts to a motor-driven mill that was 2.6 miles away from their generator. The brothers wanted to push that distance farther, and on June 7, 1898, they successfully sent 44,000 volts of electricity from their Provo Canyon hydroelectric generators to the Captain DeLaMar's Golden Gate Mill at Mercer in the Oquirrh Mountains 32 miles away. (Courtesy of Orem Heritage Museum, SCERA.)

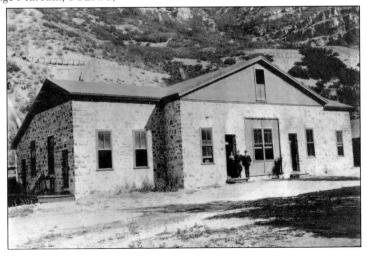

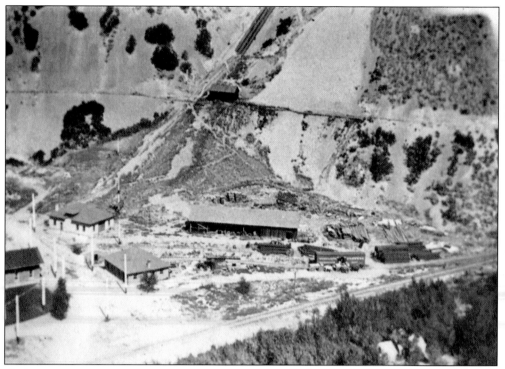

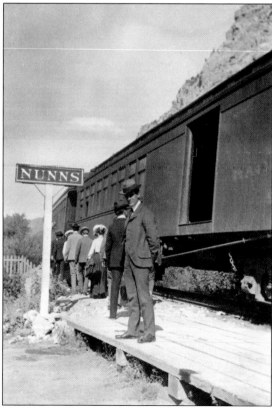

Backed by the financial capital of George Westinghouse and relying upon the technology of his brother, Paul, Lucien Nunn developed an efficient method to generate cheap and reliable electricity and to transmit it via alternating current across vast distances. Although Nunn found an ally in Reed Smoot, he found a rival in Jesse Knight, whose Knight Power Company now faced new competition from Nunn. This aerial view captures the extent of Nunn's original 44,000 volt hydroelectric power plant. Nunn contracted with the Denver and Rio Grande Western Railroad and secured his own train stop. After the Olmstead plant was completed, Nunn used the old station for storage. Later Nunn's Station was sold to Utah Power and Light and eventually to Utah County Parks, who turned it into Nunn's Park, an overnight camping area along the Provo River Parkway around 1980. (Courtesy of Kroch Collection, Telluride Power Company.)

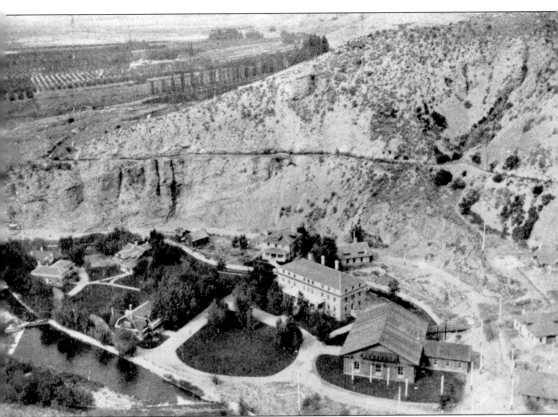

Following 1898, the demand for electricity (mainly from mining operations) continued to increase, and the Nunns recognized that they needed a larger facility. In addition, they realized they could harness increased water pressure at the mouth of Provo Canyon. In 1903, construction began on their new power station, just at the mouth of the canyon. Finished in 1904, the Nunns named their new station the Olmstead Power Plant to honor one of Paul's assistants who had died of tuberculosis before the plant was finished. Along with an improved generator facility, Olmstead also featured a building for the Telluride Institute (the building with three chimneys beside the generator building) along with several cottages for the chief technicians. The orchards on Provo Bench are clearly visible in the upper left corner. (Courtesy of Utah State Historical Society.)

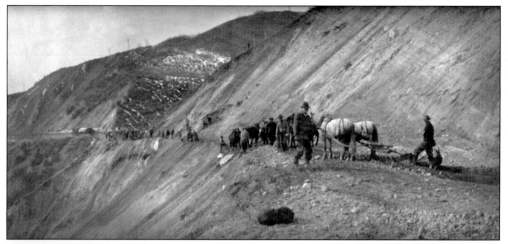

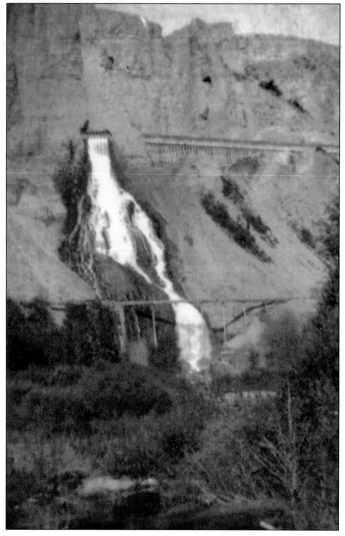

Originally the Nunns had wanted to build an 80-foot-high dam to harness the water power, but the residents of Provo and Orem feared that any dam would eventually break and flood their towns and fields. The Denver and Rio Grande Western Railroad Company insisted on having their right-of-way through the canyon. Nunn improvised, diverting water to turn the turbines by constructing wooden flumes along the canyon wall and diverting water from the Provo River and then using gravity to generate electricity from the falling water. Crews with muscle and horsepower dug grade and constructed the wooden flumes along the side of Mount Timpanogos on February 15, 1914, repairing a break at Station 168. By February 18th, the wooden flume was in place. It channeled a steady flow of water to the generating plant. The flume also came equipped with an overflow. (Courtesy of Lon Bowen.)

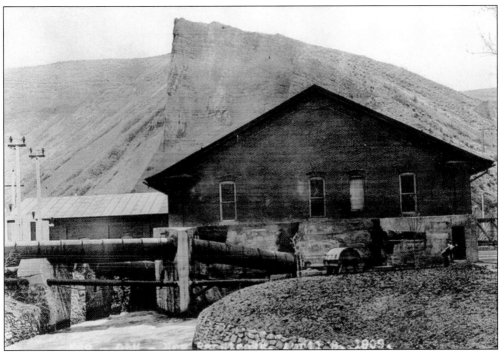

The water traveled through an 8,000-foot flume, which was diverted and divided into several penstocks. Enclosed pipes cascading down the hill created additional water pressure to drive the hydraulic Leffel turbines in the Nunn Hydroelectric Plant building. Two 750 kilowatt, three-phase General Electric generators converted the turning turbines into AC power and transformers raised the voltage from 800 volts to 44,000 volts, the highest voltage of any commercial electric power system in the world. AC power was superior to DC power because it allowed for higher voltages and transmission of current over greater distances. The water returned to the irrigation canals without being diminished. (Courtesy of Jack E. Boucher, Historic American Engineering Record, Library of Congress.)

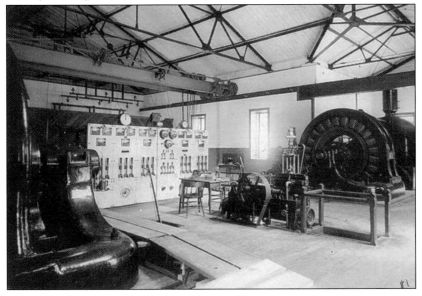

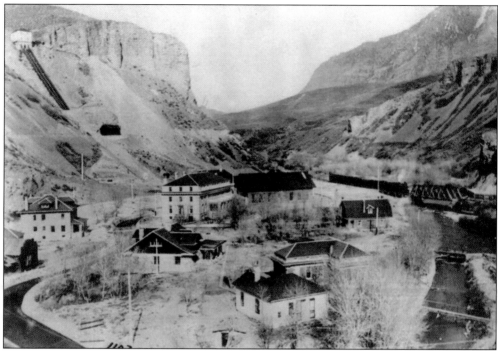

The 280-acre Olmstead facility became a miniature city. In addition to all of the electrical buildings, there were many others including Nunn's cottage, an engineer's cottage, a boarding house, an eatery, and an educational facility. Lawns, walks, flowerbeds, and canals—illuminated by arc lamps at night—complimented the beauty of Nunn's cobble rock cottage (pictured here in July 1906), which allowed Nunn to be on-site and near his technicians, workers, and students. (Courtesy of Jack E. Boucher, Historic American Engineering Record, Library of Congress and Utah State Historical Society.)

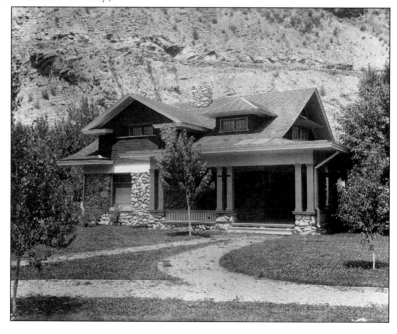

Recognizing the importance of their groundbreaking work in electricity, the Nunns established the Telluride Institute to train the first generation of formal electrical engineers. In association with Cornell University, the Telluride Institute offered a two-year program, where students could live, study, research, and work at the station. The building contained classrooms, a library, and living quarters. (Courtesy of Utah State Historical Society.)

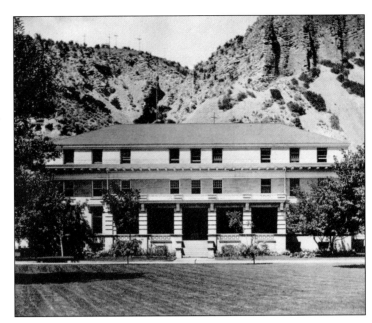

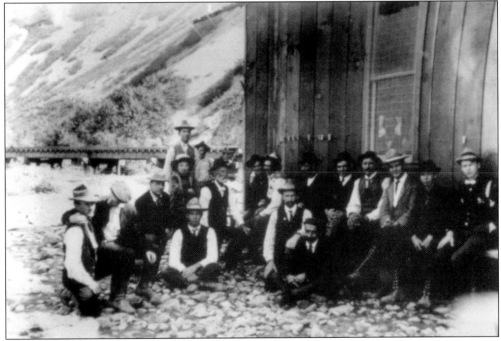

Students or "pinheads" of the Telluride Institute attended classes after their work shifts to learn about machinery, shop work, wiring, and insulating, as well as history, English, German, algebra, geometry, physics, drawing, and public speaking. Their education was truly unique, not only for its breadth, but for the fact that only the Telluride Institute and Ohio State offered any training in electrical engineering at the time. Their success made Olmstead one of the premier sites for electrical engineering research and instruction. (Courtesy of Lon Bowen.)

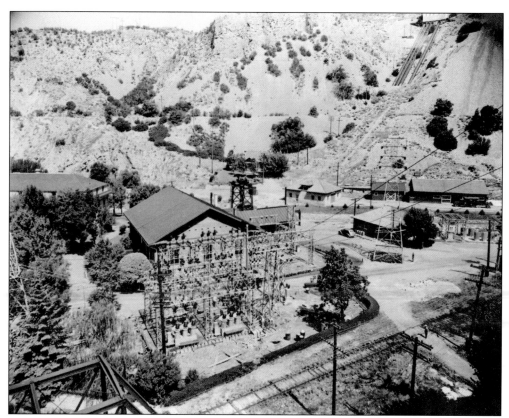

Olmstead provided electricity to Provo Bench in 1912. Nunn expanded operations in Colorado, Utah, Wyoming, and Idaho before selling all of Telluride Power Company and its assets to a New York holding company, Electric Bond and Share Corporation, for nearly $2 million. Its subsidiary, Utah Power and Light, took over production and bought out smaller companies like Jesse Knight's Consolidated Power. Although they closed the Telluride Institute in 1922, Utah Power and Light built a *House of Ideas*, equipped with the latest electrical conveniences, which thousands came to tour. The Orem Power Station, pictured here in 1914, provided the distribution of electrical power throughout Utah Valley and to other parts of Utah. (Courtesy of Utah State Historical Society.)

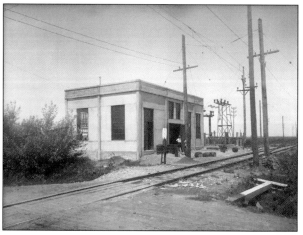

Four

A Man, a Train, a Town

Ever since the Union Pacific and Central Pacific Railroads met at Promontory Summit on May 10, 1869, railroads have been an important part of Utah's heritage. In addition to the freight lines and spurs, commuter lines gradually gained popularity. Simon Bamberger and his son Julian Bamberger built lines extending from Salt Lake to resort destinations, like Lagoon and Saltair. In Ogden, David Eccles created the Ogden Rapid Transit Company to offer some competition. In Utah Valley, fruit promoters from the Provo Bench Commercial Club recruited Walter C. Orem (pictured), president of the Salt Lake and Utah Interurban Railroad to construct an "Orem Line" extending from Salt Lake City to Payson to transport their fruit. As an incentive for the railroad owner, they renamed the Provo Bench in his honor, after officially incorporating as the town of Orem in 1919. (Courtesy of L. Tom Perry Special Collections, Brigham Young University.)

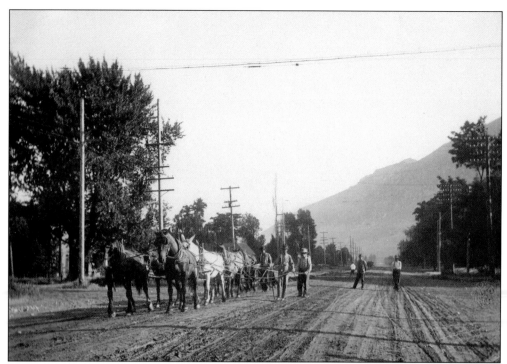

Orem obtained a $2-million loan and began surveying the rights-of-way. Two-man teams with six horses harnessed together plowed the furrows and graded the roadbed. Workers constructed overpasses, installed ties, and laid the track. Four Utah Power and Light substations powered the interurban railroad in addition to the streetcars connecting the main line to the Brigham Young Academy Provo campus. (Courtesy of LDS Church History Library.)

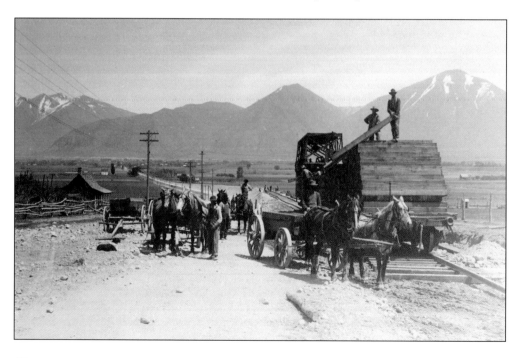

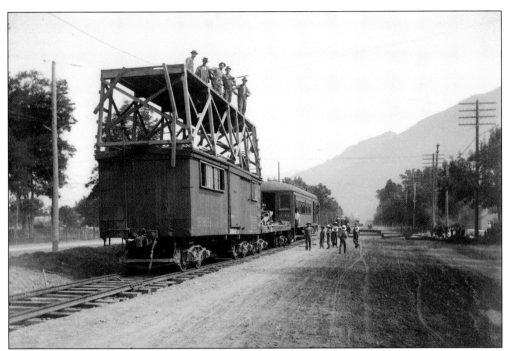

One of the final tasks was stringing the overhead catenary to carry up to 1,500 volts of electricity to power the trains. Five men ride atop a double-stacked railroad car as a group of boys keeps an eye on their work. (Courtesy of L. Tom Perry Special Collections, Brigham Young University.)

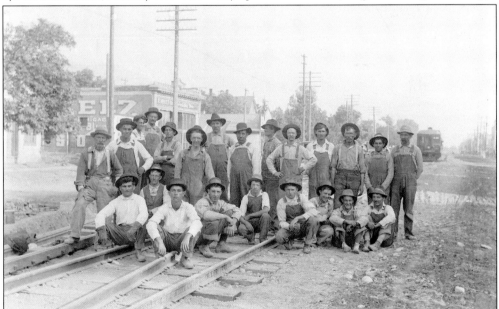

Track layers, line men, and section men like these gathered near the Orem Switch to check the tracks to make sure they were in good order and fully operational. By 1913, four gas-and-electric trains traveled from Salt Lake to American Fork daily. Within a year, nearly 1,000 passengers rode the interurban. By 1915, the train had reached Springville. (Courtesy of L. Tom Perry Special Collections, Brigham Young University.)

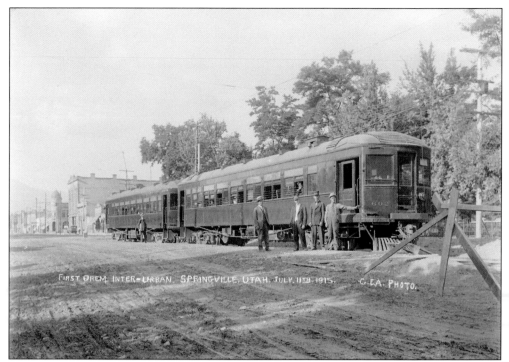

Walter Orem participated in the Pioneer Day parade July 24, 1915, to commemorate his train service arriving in Springville. While Walter Orem never lived in Orem, he did purchase 40 acres near 800 North and State Street as an investment, since he hoped the town would centralize there. (Courtesy of L. Tom Perry Special Collections, Brigham Young University.)

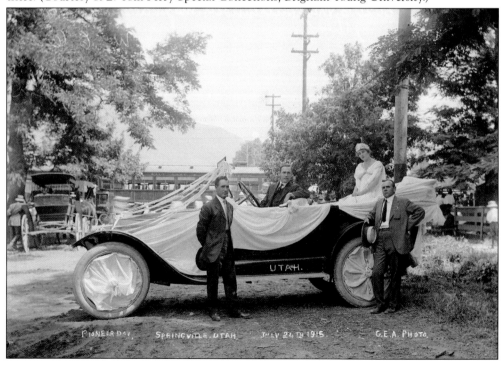

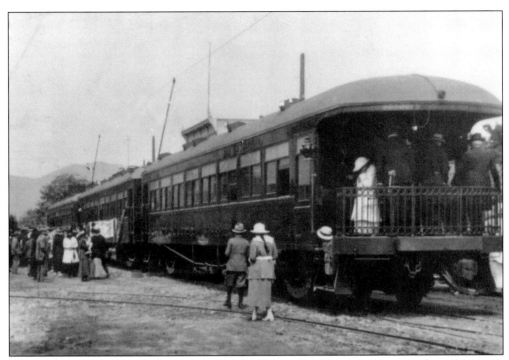

The full length of track was finally completed in May 1916. Moreover, the Strawberry Reservoir had been built to redirect water to Utah Valley. Men cut a canal through a mountain to send that water down the Diamond Fork before it arrived in Spanish Fork. Utah Valley residents celebrated the arrival of additional irrigation water and the coming of the Orem Line at a Strawberry Water and Orem Line Completion celebration. People traveled by buggy and car from near and far to commemorate the event at a special ceremony May 26-27, 1916, in Payson. (Courtesy of L. Tom Perry Special Collections, Brigham Young University.)

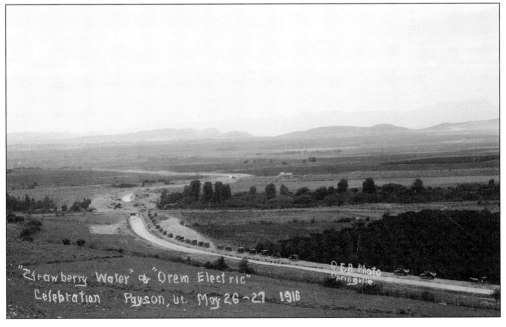

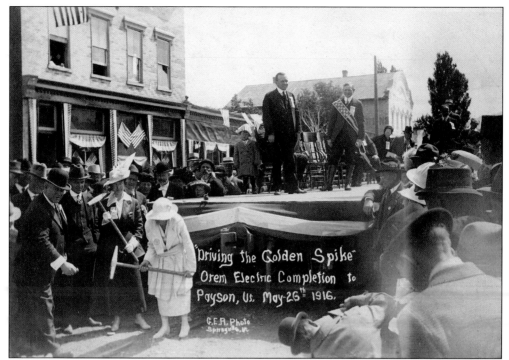

On May 26, 1916, the Salt Lake and Utah Railroad hosted a ceremony to drive a ceremonial golden spike to complete the line. Standing center stage, Walter C. Orem watches with the crowd, as two ladies await their turn to hit the spike. Following the ceremony, a banquet toasted Orem as the guest of honor. (Courtesy of L. Tom Perry Special Collections, Brigham Young University.)

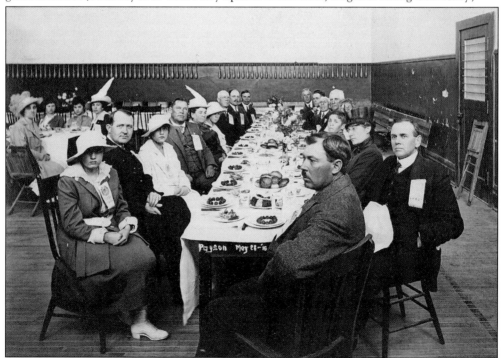

Beginning in Salt Lake and running 67 miles south to the town of Payson, the Orem Line provided service for delivering goods, parcels, and persons—and became a vital lifeline for the developing communities in Utah Valley. The line made 39 stops throughout the valley. While trains had passed through the valley for years, none had been able to connect so many communities nor offer such convenient personal transportation. Fueled by electricity rather than coal, the Orem Line ran directly through the towns, saving passengers, farmers, and businesses the inconvenience of having to travel to distant depots in neighboring towns. (Courtesy of L. Tom Perry Special Collections, Brigham Young University.)

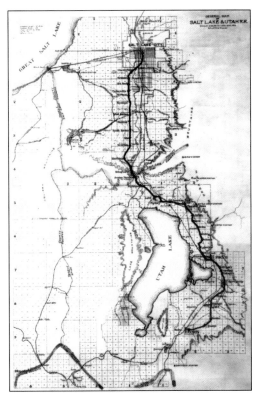

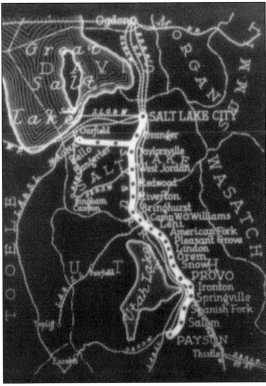

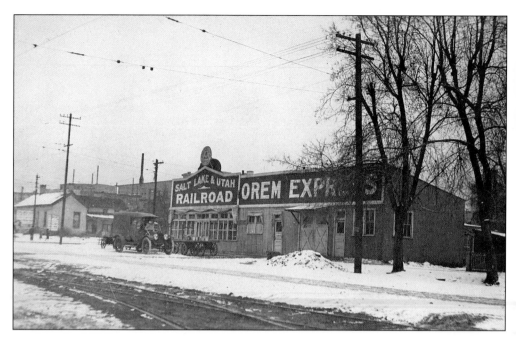

Along with prosperity, the line also gave the Provo Bench its name. Before 1914, the Bench operated as a separate entity from the town of Provo. Eventually the residents of the Provo Bench wanted to be a town in their own right, and so they needed a new, unique name. At a meeting in April 1914, the residents chose Orem as their name (Sharon and Timpanogos were the other choices), and their decision was officially recognized in 1919 when the Bench was organized into the Orem township. This picture of the Salt Lake and Utah Railroad depot in Orem reflected their pride in their new name. Meanwhile the Orem Depot coordinated the schedules for trains traveling the line. (Above, courtesy of Orem Heritage Museum, SCERA; below, courtesy of Utah State Historical Society.)

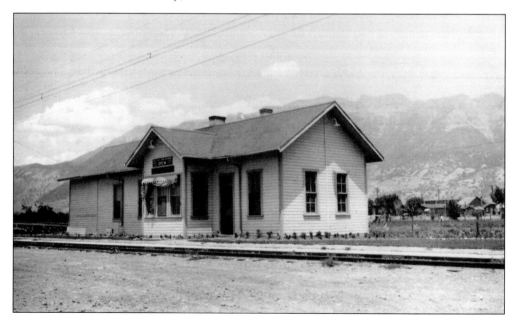

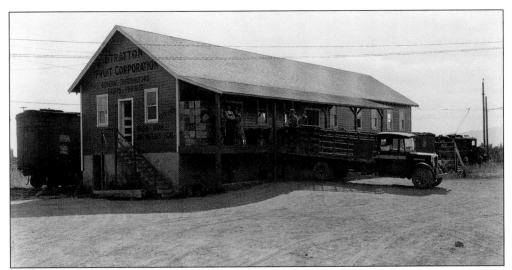

Orem's new name proved beneficial to orchard operations such as the Stratton Fruit Corporation. With the Orem Line running right beside their depot, they could easily load Orem's fruit and produce onto cars headed locally to Salt Lake City or to distant locations like Los Angeles, California. They proudly labeled their crates with Orem's name, helping their customers recognize their exceptional fruit. The Orem Express appreciated the business generated from the valley's growers. (Courtesy of Orem Heritage Museum, SCERA.)

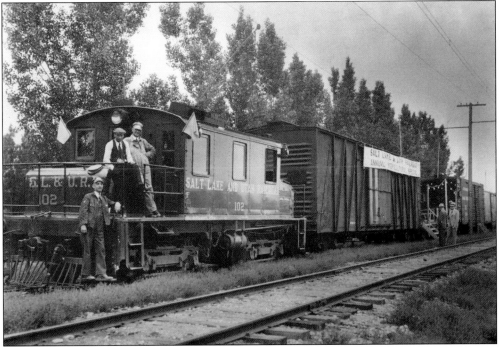

To further increase that business, the Salt Lake and Utah Railroad offered special annual rates for agricultural shipments, advertised by a banner on this train. With these deals, the Orem Line maintained committed and loyal customers. For example, in 1929 railroads carried 817 carloads of Utah fruits and 2,767 carloads of Utah vegetables from the valley, mostly to markets on both coasts. (Courtesy of L. Tom Perry Special Collections, Brigham Young University.)

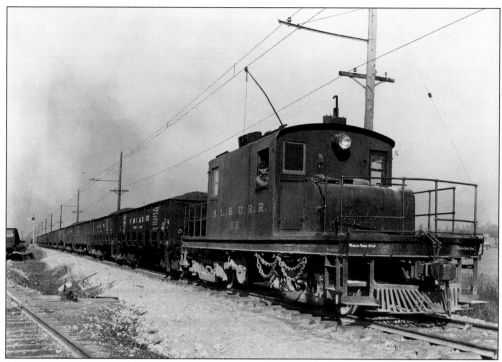

Along with spurring agricultural development, the Orem Line played an important role in helping the valley's industries. The Salt Lake and Utah Railroad helped to ship Utah's natural resources to distant markets, such as the train pictured above carrying coal bound for Alaska. With this increased wealth, larger industries began to crop up, in turn requiring more goods from outside the valley. The train pictured below is hauling oil to a refinery to convert to gasoline for the growing number of automobiles. (Courtesy of L. Tom Perry Special Collections, Brigham Young University.)

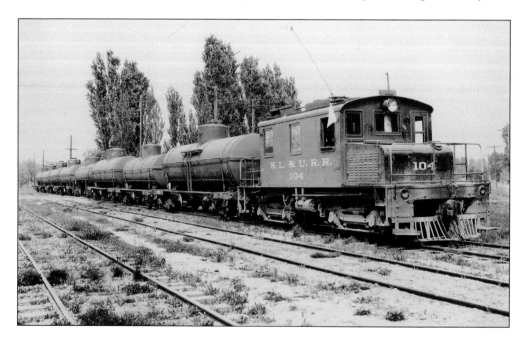

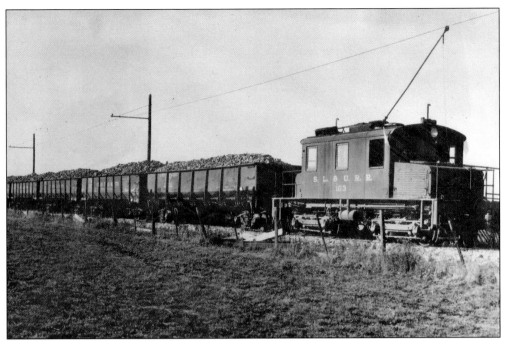

With the combined business from all of these industries, the Salt Lake and Utah Railroad carried an incredible amount of goods. In 1929 alone, the Orem Line carried 8,099 carloads of coal, gasoline, fruit, and produce. Here a train carries several carloads of sugar beets, simply dumped into the cars, there being too many to ship by crate. (Courtesy of Orem Heritage Museum, SCERA.)

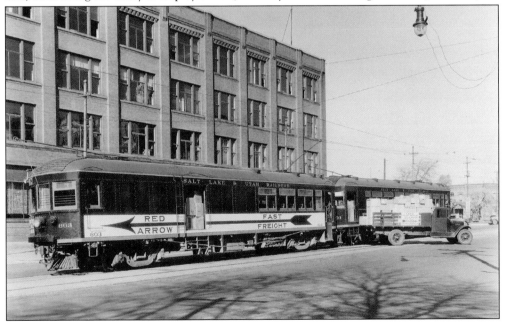

The Salt Lake and Utah Railroad also provided parcel shipment aboard their regular trains. However for freight that needed to be shipped with greater speed, the Orem Line offered the Red Arrow Freight service, which promised to ship any parcel with the greatest speed possible. (Courtesy of Orem Chamber of Commerce.)

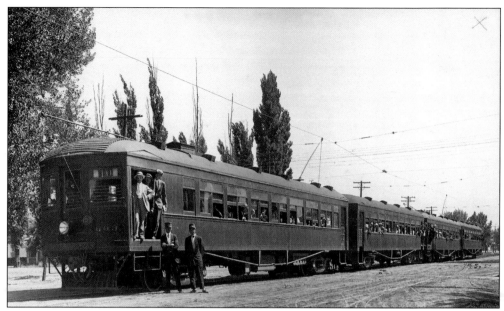

The Orem Line quickly capitalized on personal transportation. With the line running through every major city and making frequent stops, it was incredibly easy, convenient, and comfortable to travel to or from Salt Lake City. Students and families took the opportunity to hop on the train and ride to Salt Lake to enjoy a weekend of entertainment. Excursions on the "Orem" interurban train to Salt Lake City were exciting. Brigham Young University students often rode the train to attend ball games or sit in the "peanut gallery" at the old Salt Lake Theater. (Courtesy of L. Tom Perry Special Collections, Brigham Young University.)

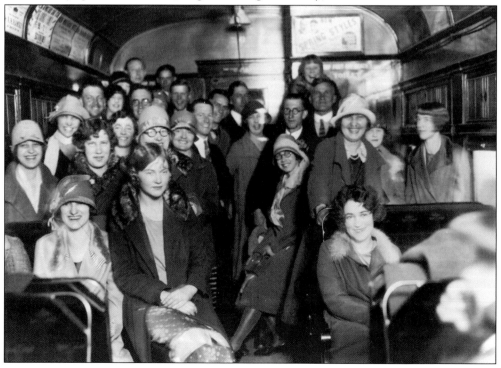

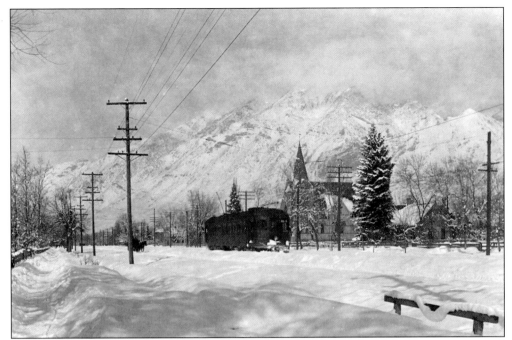

By 1930, the Orem Line began losing ridership as automobile use increased. While business remained strong with agricultural and bulk freight, the Salt Lake and Utah Railroad was unable to thrive after losing its parcel and passenger business. (Courtesy of LDS Church History Library.)

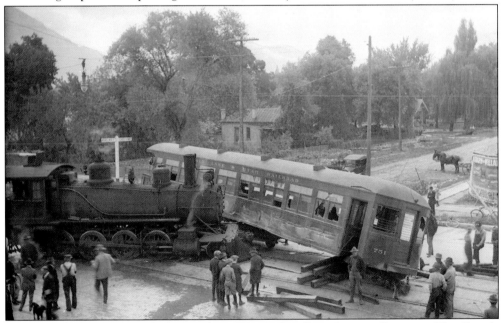

Sometimes, human error resulted in accidents. This crash in Provo between Denver and Rio Grande Western Railroad Locomotive 592 and Salt Lake and Utah Railroad 751 on October 4, 1918, illustrates a dramatic collision of freight and passenger trains. Fourteen passengers received injuries, including Provo's mayor, LeRoy Dixon. (Courtesy of L. Tom Perry Special Collections, Brigham Young University.)

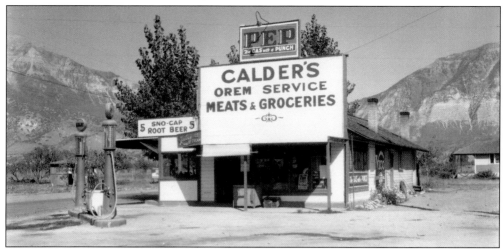

In the end, the Orem Line would not be outdone by a competing railroad, but by the humble gas stations, like Calder's (built in Orem in 1929). They sprouted like weeds throughout the valley, marking the rising popularity of the automobile—not only for families wanting more convenience, but also for shipping companies that could ship a crate of fruit from Orem to California without having to change lines, coordinate switches, or worry about schedules. (Courtesy of L. Tom Perry Special Collections, Brigham Young University.)

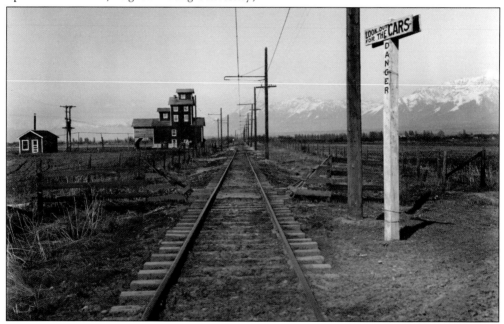

When automobiles began crossing rail lines, the Orem Line built signs like these to help their conductors to be more alert and to help prevent accidents. These signs admonishing train drivers to watch out for cars contained a double meaning. Oil companies and automobile businessmen led a campaign to buy up interurbans so they could shut them down. After the spread of the automobile helped push the Salt Lake and Utah Railroad toward foreclosure, these signs had a prophetic irony, and by 1947 the last interurban railroad line in Utah ceased operation. History does repeat itself ,and Utah Valley is undergoing a project to bring commuter and light rail service back to the area by 2015. (Courtesy of Utah State Historical Society.)

Five

THE MEN OF STEEL

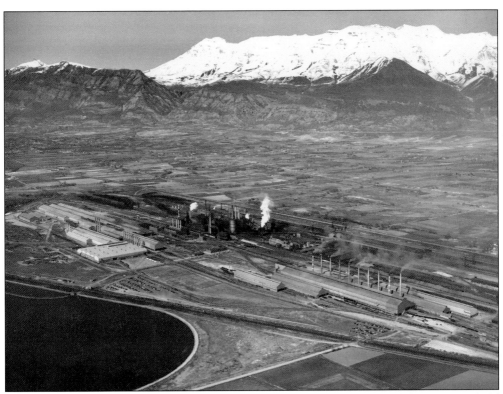

Every week, Orem newspaper subscribers read "Orem–The Steel Center of the West" in bold font across the front page of their *Orem-Geneva Times*. The strategic importance of a steel mill in the nation's interior took on added significance during World War II, following the Japanese attack on Pearl Harbor. Geneva Works of the Columbia-Geneva Steel Division, United States Steel Corporation, represented the West's largest integrated steel operation, stretching out over 1,725 acres at the foot of Mount Timpanogos in Orem, Utah. Behind the plant can be seen the well-ordered pattern of the valley's farms. (Courtesy of Utah State Historical Society.)

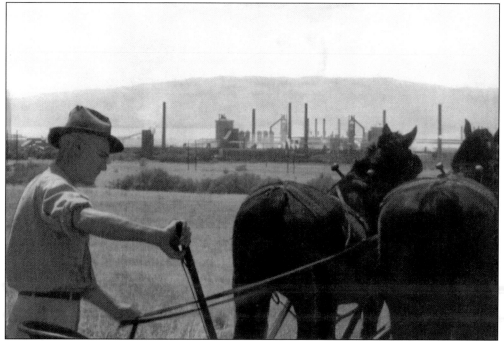

Orem's agricultural past underwent a change in the 1940s. As steel demands increased during World War II, the federal government stepped in to construct additional steel mills to answer the growing need. The Geneva Steel Mill marked Orem's transition from agriculture to industry, a shift hastened in the following decades. The plant displaced 40 farms in Vineyard, including 17 dairy operations. Orem annexed part of Vineyard and other areas in 1943 (Vineyard later incorporated in 1989), and farmland gradually gave way to residential and commercial development. (Courtesy of Orem Heritage Museum, SCERA.)

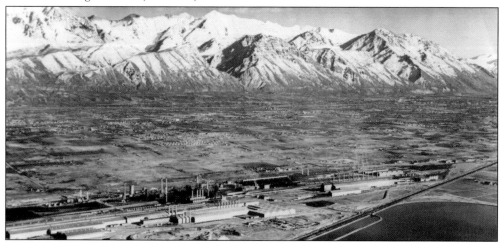

With only a handful of comparable mills in the West, the federal government built a new steel plant in the Rockies to help address the growing needs of the American West and to help support the war industries along the Pacific coast that were preparing for war against Japan. Orem was selected as an ideal site, since its inland location protected it from a Pacific invasion, while also putting it closer to raw materials (coal, iron, limestone, dolomite) mined in Utah. (Courtesy of Orem Public Library.)

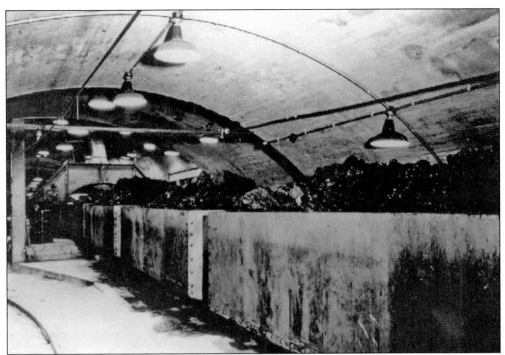

Aptly-named Carbon Country in southeastern Utah contains extensive coal beds with approximately 13,000 square miles of high-grade bituminous coal, yielding approximately 196 billion tons of coal. The Geneva Mine in Horse Canyon was built for World War II steel production. The coal was turned into coke that could be sold or used as fuel in the blast furnaces. Meanwhile, mining Utah iron ore was accomplished with power shovels in Iron County. This iron ore of the Columbia Iron Mining Company was usually at least 45 percent pure and could be shipped to smelters in central Utah, and then converted into steel at Geneva. (Courtesy of Utah State Historical Society.)

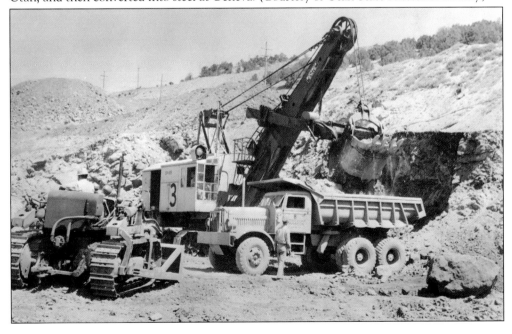

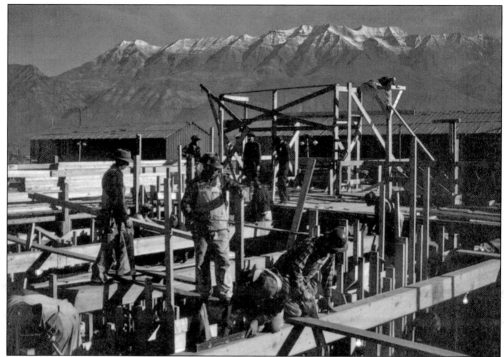

The Columbia Steel Company hired thousands of workers in order to undertake the mammoth project. Construction of Geneva Steel began in November 1941 and continued through December 1944. The entire project involved over 10,000 workers and was projected to cost around $200 million. However, repeated delays, shortages, and complications made the plant far more expensive. (Courtesy of Andreas Feininger, Farm Security Administration, Office of War Information Photograph Collection, Library of Congress.)

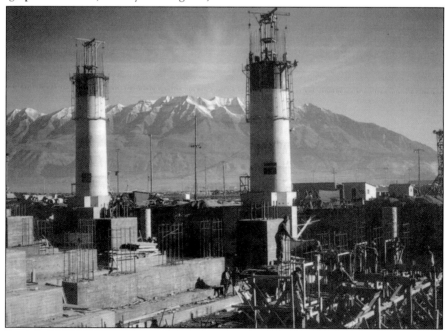

Hundreds of tasks need completing. Workers ran surveying lines for water intake tunnels while others assisted with excavations for the open-hearth furnaces. Others mixed and poured concrete, worked drag lines, or set pipes with derricks to help the mill take shape. This bulldozer operator handled grading and excavation as well as pushing gravel for making concrete. (Courtesy of Andreas Feininger, Farm Security Administration, Office of War Information Photograph Collection, Library of Congress.)

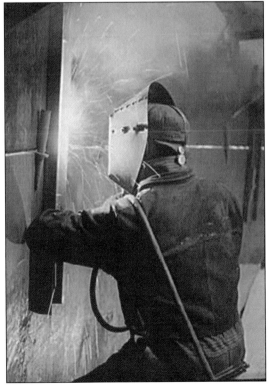

An arc welder employed his craft in making continuous welds strong enough to handle the temperature fluctuations, pressure, and stress they faced in the ensuing years. Like those welds, Orem braced itself for the challenges and opportunities the mill brought. (Courtesy of Andreas Feininger, Farm Security Administration, Office of War Information Photograph Collection, Library of Congress.)

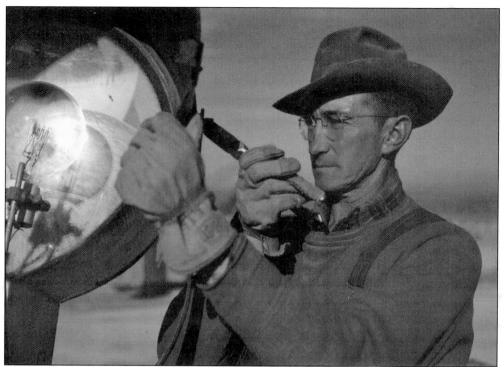

In order to stay on schedule, the company erected lights to enable workers to work around the clock. Above, a worker services one of the floodlights that turned night into day at the huge construction site, while the nighttime photograph below shows just how light it could be. (Courtesy of Andreas Feininger, Farm Security Administration, Office of War Information Photograph Collection, Library of Congress.)

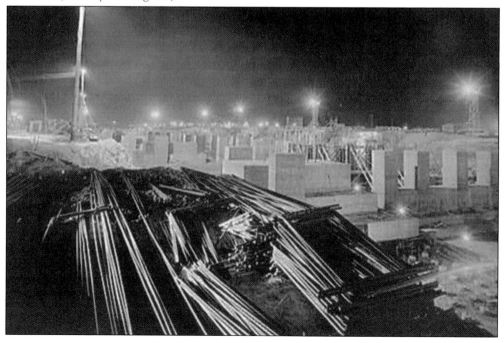

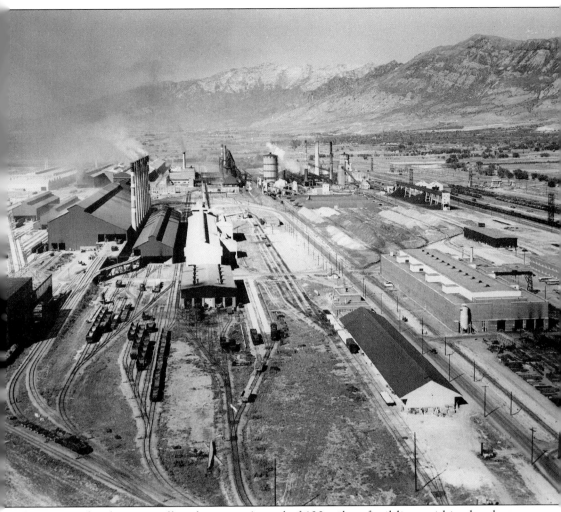

Orem proved to be an excellent location. A total of 100 miles of rail lines within the plant connected to others running to all parts of the country. Utah Valley provided an educated and reliable workforce. Steelworkers Local 2701 functioned as the union for employees. Geneva Steel Works entered a period of colossal construction of buildings, elevated conveyors, blast furnaces, cooling ponds, and railways. (Courtesy of L. Tom Perry Special Collections, Brigham Young University.)

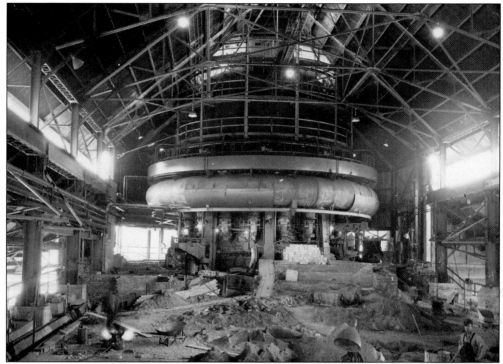

Geneva Steel utilized three interior cast house blast furnaces (including furnace number three, pictured here in 1944), each fueled by three stoves. The furnaces produced 3,600 tons of hot pig iron daily that was then smelted into steel products such as hot rolled sheets, coils, floor plates, normalized place, and wide flange beams. (Courtesy of L. Tom Perry Special Collections, Brigham Young University.)

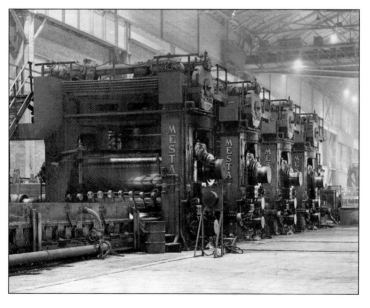

Workers and machines shaped the refined ore into whatever their customers needed. During the years of the war, a majority of their steel was made into plate steel and structural shapes for the wartime shipbuilding industry on the West Coast. Geneva also filled commercial orders not tied directly to wartime production, including steel piping used for expanding oil pipe lines. (Courtesy of Orem Heritage Museum, SCERA.)

Although Geneva Steel helped to establish Orem through the steel it produced, its greatest contribution was through the men it employed. When it first opened in 1945, Geneva Steel had over 5,000 workers and was the largest employer in Utah. Orem's population more than doubled. The 1940 U.S. Census listed Orem with a population of 2,914. According to the 1950 U.S. Census, only five years after Geneva Steel opened, the population had grown to 8,351. (At right, courtesy of L. Tom Perry Special Collections, Brigham Young University; below, courtesy of Utah State Historical Society.)

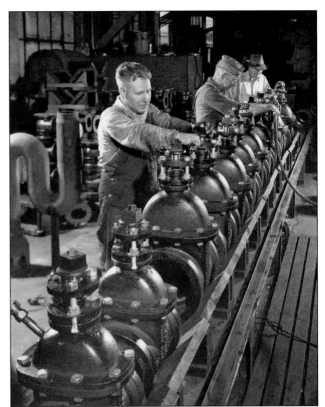

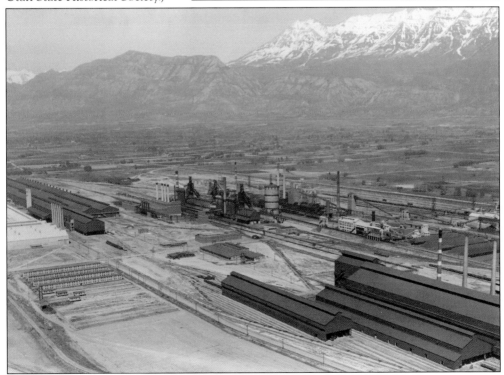

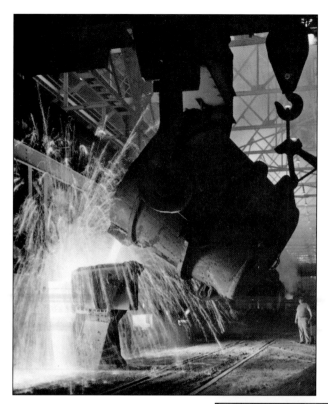

Despite the plant's success during the war, the federal government began soliciting buy-out offers for Geneva Steel in 1945. With the war over, the military demand for steel declined and commercial demands were not high enough to keep the plant running profitably at full capacity. (Courtesy of L. Tom Perry Special Collections, Brigham Young University.)

In June 1946, U.S. Steel purchased Geneva for $47.5 million with the stipulation that U.S. Steel would invest another $18.6 million into converting the plant to peacetime production. By any perspective, Geneva Steel was sold at an incredible bargain. The plant was valued at $144 million, nearly $100 million more than U.S. Steel's bid. (Courtesy of Orem Public Library.)

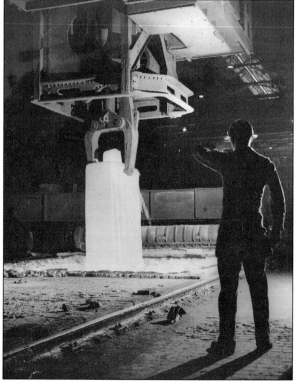

U.S. Steel continued operating the plant until 1986. While the mill had played an important role in furthering industrial progression in the American West and had significantly industrialized the surrounding towns, Geneva was proving too costly to operate. Foreign competitors, new technologies, and rising environmental concerns all worked against Geneva Steel. (Courtesy of Utah State Historical Society.)

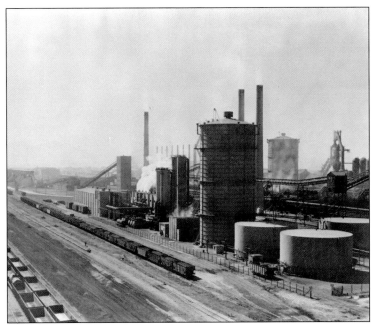

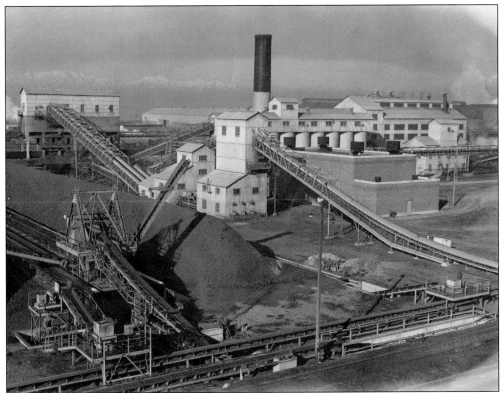

Hoping to preserve the plant, a group of Utah investors bought it for $44 million, which was less than a third of the plant's estimated liquidation value. After attempting to run the plant, they were forced to declare bankruptcy. In 2002, the dismantling of Geneva Steel began. (Courtesy of Orem Heritage Museum, SCERA.)

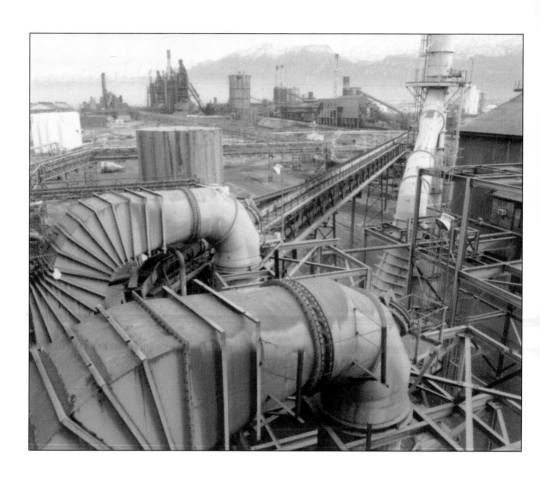

In 2002, Geneva was unable to meet its financial obligations and thereafter liquidated its assets and began demolition. The dismantling of Geneva Steel was captured by photographer Chris Dunker, who provided a splendid visual record of the end of five decades of steel-making in Orem. These images feature a 2004 north-facing view of the Q-BOP ducts and plant overview and a northeastern 2007 view of the Plate Loading Dock and Rolling Division buildings. (Courtesy of Chris Dunker.)

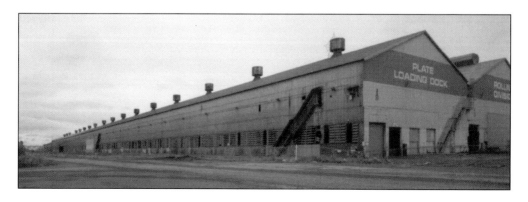

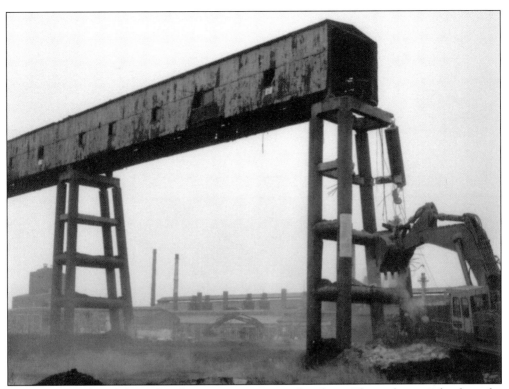

Salvaging and demolishing the plant was a massive undertaking. These photographs show the dismantling of the coal conveyers in 2004 (above) and the finishing stands in 2006 (below). (Courtesy of Chris Dunker.)

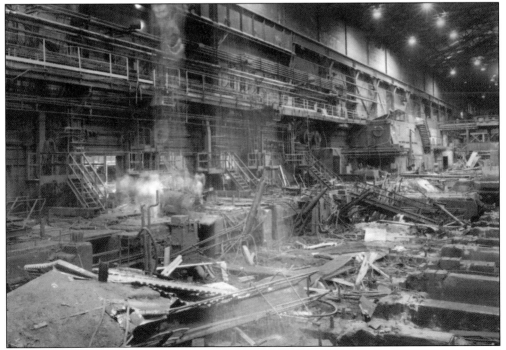

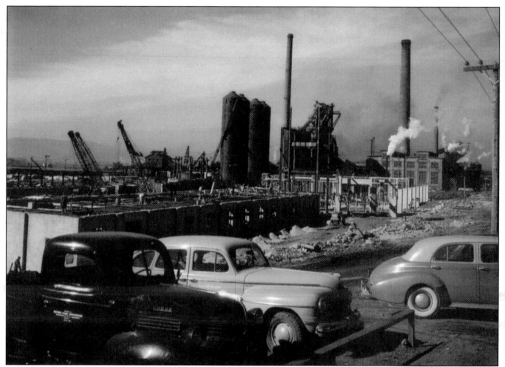

Geneva Steel was a busy construction site in the 1940s. In contrast, the central maintenance changing room in 2006 was filled with abandoned workers' clothes. Both images provide an opportunity to remember the thousands of workers who labored over the five decades of operation and put their hearts and souls into Geneva. (Above, courtesy of Andreas Feininger, Farm Security Administration, Office of War Information Photograph Collection, Library of Congress; below, courtesy of Chris Dunker.)

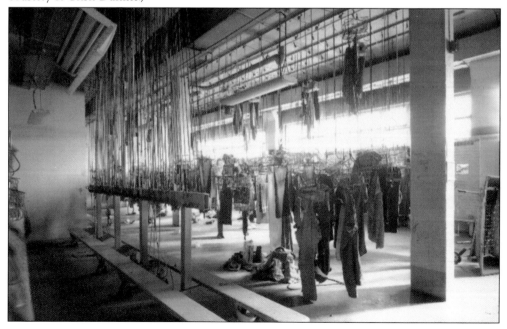

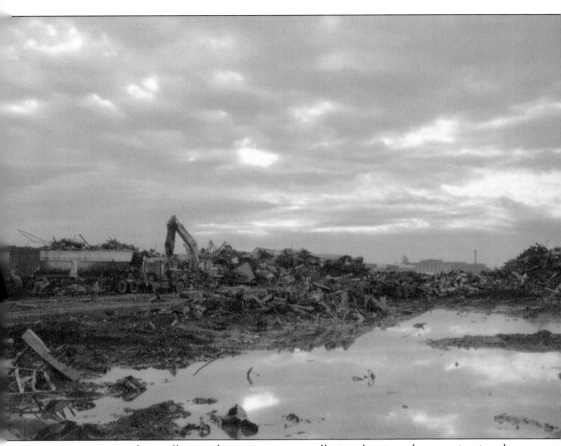

Geneva's presence took its toll upon the environment, polluting the air and contaminating the water and soil. The demise of Geneva created hardships and exacted a human toll upon thousands of workers and their families who depended upon the company for their livelihood. (Courtesy of Chris Dunker.)

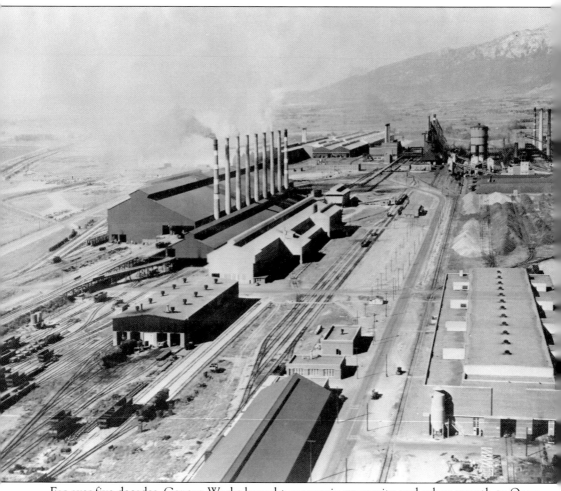

For over five decades, Geneva Works brought economic prosperity and urban growth to Orem. Geneva helped transform Orem from a rural farming community into a growing city. (Courtesy of Orem Public Library.)

Six

VOCATIONAL SCHOOL TO UNIVERSITY

Utah Valley University has undergone quite a few changes over the past 60 years. Consider the different names it has been known by: Central Utah Vocational School (CUVS, 1941); Utah Trade Technical Institute (UTTI, 1963); Utah Technical College (UTC, 1967); Utah Valley Community College, (UVCC, 1987); Utah Valley State College (UVSC, 1993); and, Utah Valley University (UVU, 2008). Low tuition and flexible schedules made it an economical choice for a practical education. An early school slogan proclaimed that "it pays to be skilled." (Courtesy of George Sutherland Archives, Utah Valley University.)

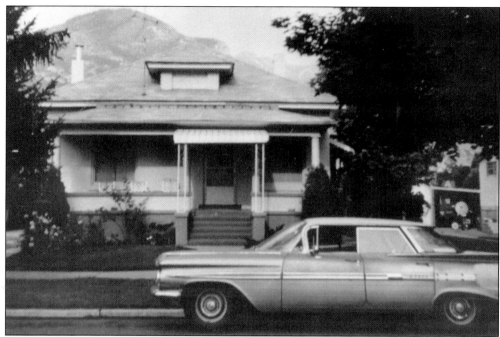

Night classes at various places in Utah County under the auspices of the Alpine, Provo, and Nebo school districts began in 1937. Established in September 1941 through National Defense funds to provide specialized and technical training, Central Utah Vocational School was one of only two Utah schools devoted solely to vocational curriculum in Trade, Industry, Business, and Distributive Education. The school began operation under humble beginnings, renting this house on 134 South and 300 West in Provo for its central office, its main operations at the abandoned Civilian Conservation Corps barracks that had comprised the Rock Canyon Camp at the Utah Country Fairgrounds at 1100 South and University Avenue in Provo. (Courtesy of George Sutherland Archives, Utah Valley University.)

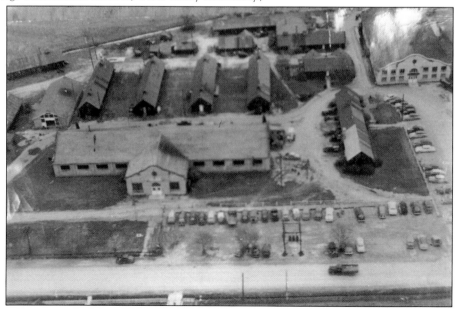

The first president of CUVS was Hyrum E. Johnson, who served during the war years from 1941 to 1945. The United States needed craftsmen to produce arms and ammunition for the war effort. Johnson gathered expertise throughout the valley to bring it to a more centralized location. Pictured below, the 1942 faculty consisted of (first row) Lucian Bates, Eldon Nelson, William Laursen, Ross Anderson, Orville Gunther, Joseph Ward, George Larsen, Verner Powell, Harold Clark, LaRel Johnson, Don Schmutz, Wilson Sorensen; (second row) Clarence Tuttle, Kathryn Sorenson, Harriett Vigen, Marian Taylor, Mayna Moffitt, Mary Snell, H. E. Johnson, Maxine Harding, Grace Croft, Maude Humphries, Lucille Hallam, Norman Whitaker, Myron Jense; (third row) John Lamph, Alfred Hayes, Delbert Fugal, Eugene Johnson, Alex Mortinsen, Everett Backman, Henry Radditz, Harrison Scott, J. W. Nielsen, Keith Hunter, Harry Forsyth, Glen Wing; (fourth row) B. M. Jolley, Ira Longhurst, Lavere Wadley, Blaine Allen, R. E. Maxfield, D. C. Brimhall, Richard Greenhand, Walter Batchler, Lynn Wakefield, Norman Geertsen, J. H. Comer, and Beryl Thayer. (Courtesy of George Sutherland Archives, Utah Valley University.)

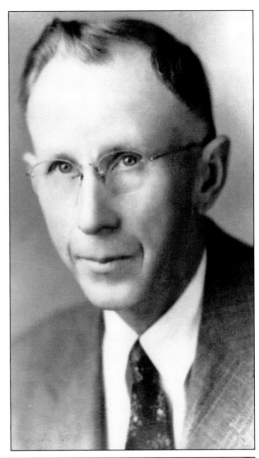

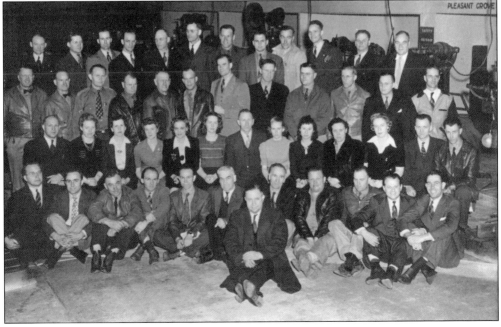

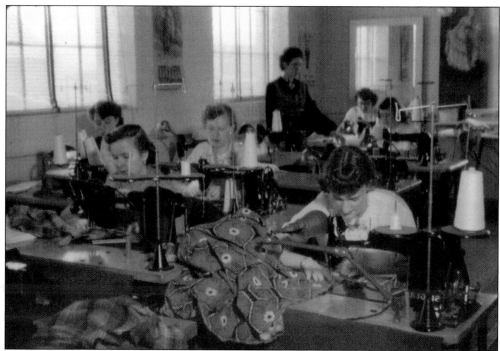

Day trade classes operated from 8:30 a.m. to 3:15 p.m. Monday through Friday, and evening classes ran from 7:00 p.m. to 10:00 p.m. Tuition cost $135 each quarter (fall, winter, spring), which covered 30 clock hours per week. Students took advantage of courses in sheet metal, power sewing, electrical wiring, meat cutting, auto mechanics, painting, radio servicing, merchandising, stenography, garment making, business, carpentry, cabinet making, auto body and fender, welding, forging, refrigeration, nursing, drafting, and many other trades. Instructor Rea Malin offers training to her power sewing class while instructor William Laursen (kneeling) teaches his blacksmithing pupils how to repair farm machinery in 1944. (Courtesy of George Sutherland Archives, Utah Valley University.)

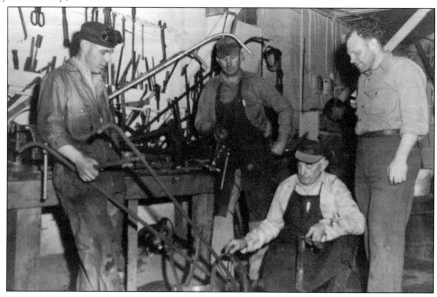

The real pioneer who shaped the history of the school was Wilson W. Sorensen, president from 1945 to 1982. With the support of his wife, Helen, Sorensen was at the helm for nearly four decades and led out in acquiring 13 acres of land west of Brigham Young University's football stadium for a new CUVS Provo campus at 1395 North and 150 East. He also oversaw the name changes to Utah Trade Technical Institute in 1963 and Utah Technical College in 1967. (Courtesy of George Sutherland Archives, Utah Valley University.)

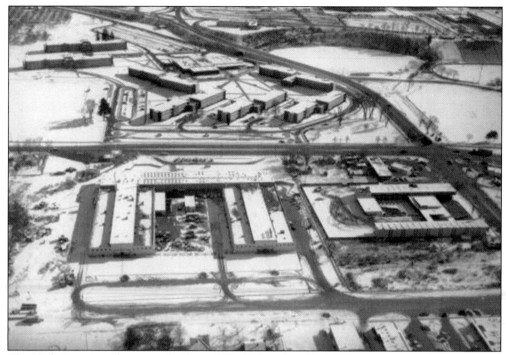

The Utah State Legislature made Central Utah Vocational School a permanent state institution in April 1945 when Utah governor Herbert B. Maw signed a bill recognizing the school as a state institution and named Wilson W. Sorensen director. The next two decades were filled with expansion, especially after Sorensen moved the school to a new campus located at 1300 North and University Avenue in Provo, completing construction of their first building in 1951. By 1967, the school became Utah Technical College at Provo and began awarding associate degrees. (Courtesy of George Sutherland Archives, Utah Valley University.)

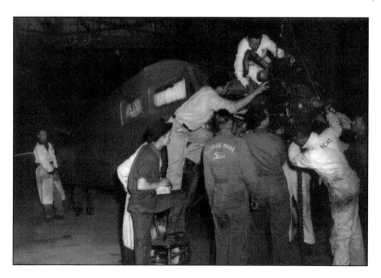

Students from the Aircraft Mechanics class purchased and salvaged engines and airplane parts. Here students install an engine at the Provo Municipal Airport, while their instructor, Hugh McLaren (white overalls with NEAT on back), assists. (Courtesy of George Sutherland Archives, Utah Valley University.)

Students enrolled in the Practical Nursing program were placed under the supervision of a physician or registered nurse and received instruction on providing physical care and emotional support to patients in a wide variety of settings. (Courtesy of George Sutherland Archives, Utah Valley University.)

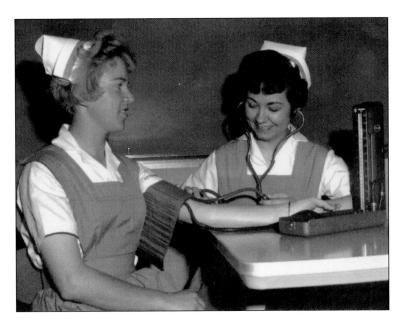

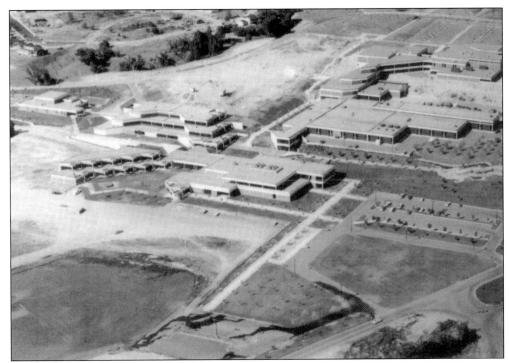

The college soon outgrew its Provo campus. Between 1966 and 1972, Sorensen had the initiative and vision to purchase 185 acres of farmland in Orem bordered on the west by Interstate Highway I-15. LDS Church president Spencer W. Kimball dedicated the new Orem campus at 1200 South and 800 West in 1977. For several years, the college offered classes at both campuses before moving entirely to Orem. (Courtesy of George Sutherland Archives, Utah Valley University.)

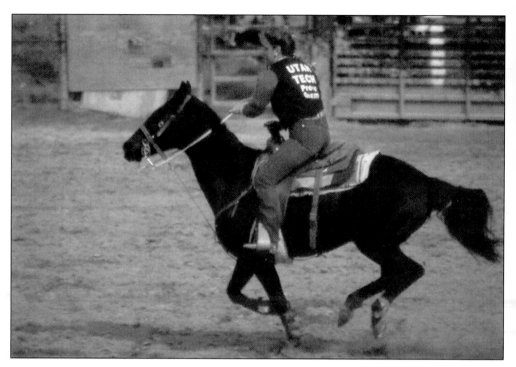

In addition to academics, the campus offered social activities hosting bands, concerts, dances, performances, antique car shows, beauty contests, and other events. Rodeo was a popular sport as well as basketball, volleyball, and other team sports. In these images, a female athlete competes in the barrel-racing event while the other depicts a UTTI basketball game played on December 2, 1966. (Courtesy of George Sutherland Archives, Utah Valley University.)

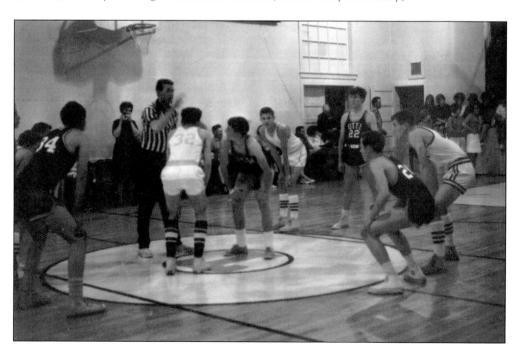

The school continued to grow by constructing buildings, adding faculty, and admitting more students. In 1969, a total of 1,000 students were enrolled. Within a decade, the number had grown to 5,000. More degree programs were made available, and demand for curriculum offerings grew. (Courtesy of George Sutherland Archives, Utah Valley University.)

In 1982, J. Marvin Higbee became the third president. In his five years as president, the college increased its offerings and became Utah Valley Community College in 1987. (Courtesy of George Sutherland Archives, Utah Valley University.)

Appointed president in 1988 and serving until 2002, Kerry D. Romesburg emphasized arts and humanities, international education, and short-term training throughout the college's curriculum. He improved the face of campus by adding and expanding buildings. His efforts helped obtain voter-approved funding for an 8,500-seat McKay Events Center on campus as well as land and buildings for the Wasatch Mountain Campus in Heber City, Utah. Under his leadership, the institution became Utah Valley State College in 1993 and began offering bachelor degrees. (Courtesy of George Sutherland Archives, Utah Valley University.)

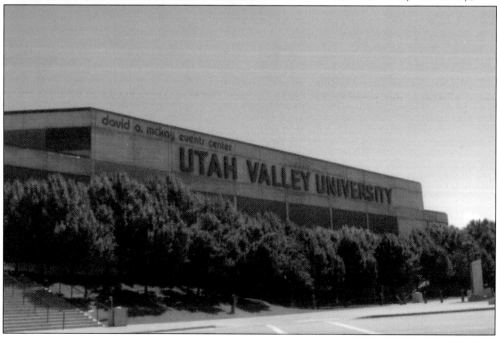

William A. Sederburg, president of Utah Valley State College from 2003 to 2009 had a distinguished career in higher education. His dynamic leadership brought about the school's transition to Utah Valley University in 2008 by building a new library facility, adding 26 new baccalaureate degrees in a variety of fields, and hiring an additional 130 faculty to teach in the degree areas to qualify as a comprehensive regional state university. The Utah State Legislature unanimously granted university status, and on July 1, 2008, the school became Utah Valley University. Then on August 18, 2008, Sederburg stepped down as president to accept a new challenge as Utah's seventh commissioner of higher education. (Courtesy of George Sutherland Archives, Utah Valley University.)

Matthew S. Holland, a political science professor at Brigham Young University, became the sixth president of the institution in 2009 and the first under the new name, Utah Valley University. The publicly funded state university retains its trade and vocational school roots, even while student numbers approach 27,000 from all 50 states and 75 countries. The university offers nearly 60 bachelor degrees, 60 associate degrees, more than 20 certificate programs, and a growing number of master's degrees. The school has come a long way from a rented house in Provo and holding classes at the Utah County Fair Grounds. As one of Orem's largest employers, Utah Valley University has found a permanent home in Orem. (Courtesy of George Sutherland Archives, Utah Valley University.)

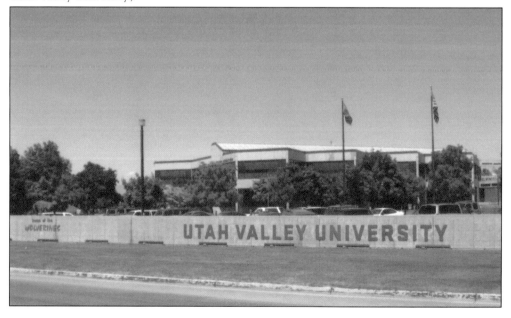

Seven

A Lake, a River, a Mountain

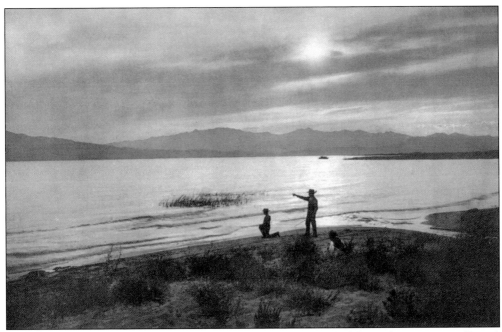

Utah Lake served as the focal point for Utah's early residents. The lake and Timpanogos (Provo) River held innumerable trout that provided sustenance in the early years. The lake was a popular place for fishing, boating, and picnicking. In the wintertime, men with teams of horses pulled wagons onto the frozen surface and people cut ice blocks to take home and keep their food cool in the summer months. People also enjoyed traveling up Provo Canyon to sightsee, ride the train, or ski. By the mid-20th century, Mount Timpanogos had replaced Utah Lake as the focal point for much of Utah Valley. (Courtesy of Library of Congress.)

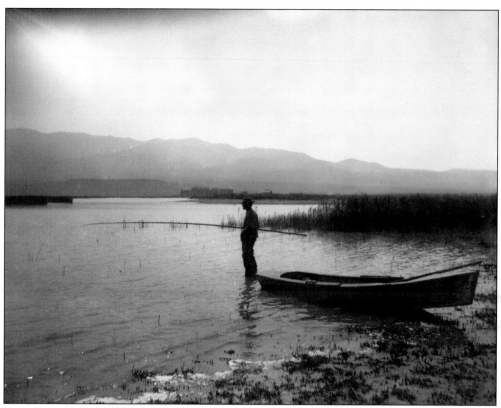

Since the early days, Utah Lake had been a natural recreation spot. In the summer, local farmers took their families down to the lake, where the clear blue water reflected the beauty of the mountains around them. Fishing was popular, since the river and lake contained Bonneville Cutthroat Trout. (Above, courtesy of Utah State Historical Society; below, courtesy of L. Tom Perry Special Collections, Brigham Young University.)

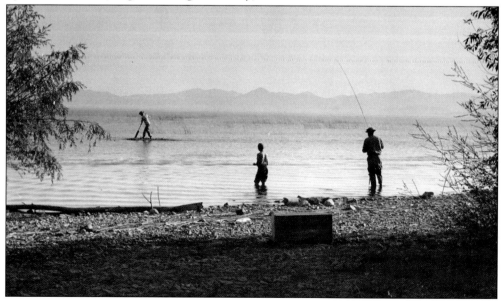

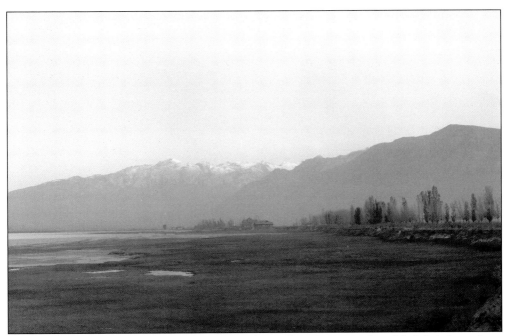

In 1888, Capt. John Dallin from Springville, Utah, purchased 10 acres along Utah Lake's northern shore near the present-day Lindon/Orem Boat Harbor. Along with building a small home for his family, he planted poplar trees, dug an artesian well, and established a bathing resort with two pools and a slide. He named it the Geneva Bathing Resort after his daughter Geneva, and it operated from 1890 to 1935. (Courtesy of Utah State Historical Society.)

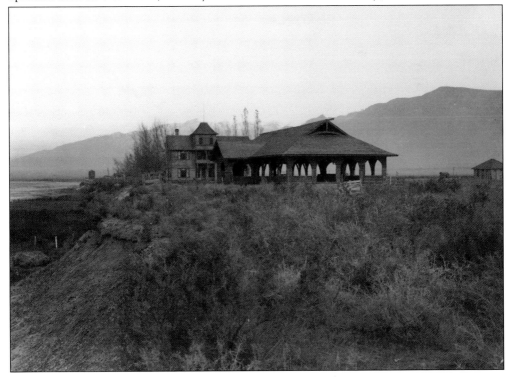

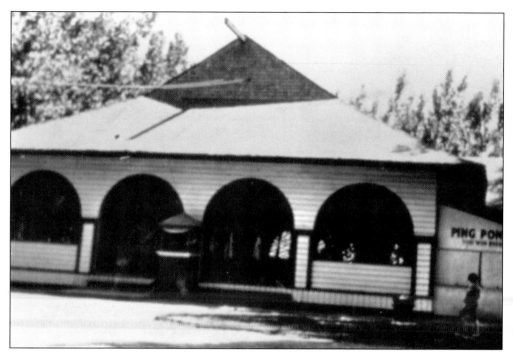

Over the next five years, Dallin continued to develop the resort, adding a boat harbor, a dance pavilion, a two-story hotel, and a saloon. He organized horse races, boat races, ball games, fishing, and shooting matches. With so much to offer, the Geneva Bathing Resort attracted scores of people, so much so that the Denver and Rio Grande Western Railroad built a link from their main line that serviced the resort. (Courtesy of Lon Bowen and Hollis Scott.)

Sometime before 1900, Dallin obtained a bear from the canyon (pictured here with Agnus Taylor) that entertained guests. Although the animal was harmless, patrons of the resort (the saloon in particular) spread rumors that Dallin fed his drunken guests to the bear. As successful as the resort had been, every season depended on the height of the water. After a few years with low water, Dallin sold the resort in 1907. Between 1907 and 1935, the resort property was sold five times before the resort burned to the ground. In 1959, the Orem City Council became interested in the old Geneva Resort site. Leasing the property owned by the adjacent Town of Lindon, they built a pleasure boat harbor and named it Orem Marina Park. (Above, courtesy of Lon Bowen and Hollis Scott; below, courtesy of LDS Church History Library.)

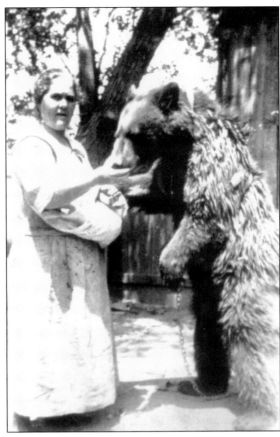

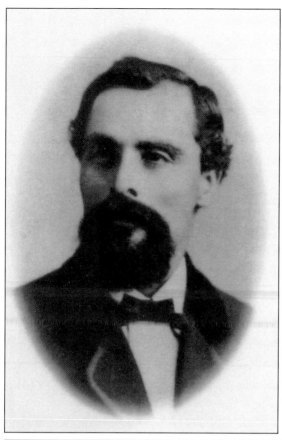

Orem has long held a reputation as a beautiful place for rest and relaxation. With Mount Timpanogos to the East and Utah Lake to the West, there was always something to do including skiing, swimming, hiking, fishing, camping, or boating to name a few. Jorgen Christian Nielsen contributed to this notion with his beautiful Lake View Garden. After immigrating from Denmark, Jorgen and his wife settled on the Provo Bench, building a small three-room home at the crest of the hill about 500 feet from the corner of 2000 South and Sandhill Road where they reared eight children. The house had wood siding and wood shingles. Nielsen had a green thumb, acquired from his uncle who had designed the world-renowned Kongens Have Garden in Denmark, and he set out to create a similar park in Orem. (Courtesy of Nielsen's Grove Museum, Orem Historic Preservation Commission)

Nielsen created a fountain, numerous picnic gazebos, an open-air dance floor, and planted numerous vines, flowers, and trees. This was one of the most beautiful gardens in the West. After landscaping the area, he constructed a circle-swing with 12 seats, driven by the force of two men or mules who circled the central beam. To finance their efforts, Mrs. Nielsen sold homemade ice cream, popcorn, soda water, and sandwiches. (Courtesy of Nielsen's Grove Museum, Orem Historic Preservation Commission.)

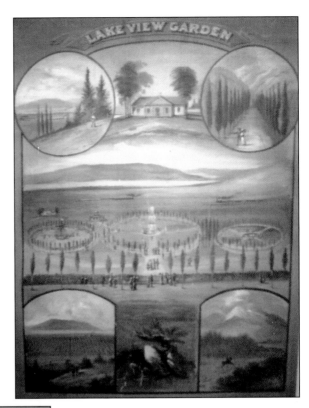

After Nielsen's death, Lake View Garden suffered from neglect until its beauty was only a memory. Orem City purchased the land in 1999 and reconstructed Nielsen's Grove after Nielsen's original design, with the addition of a monument and museum to honor the man who created one of Orem's most beautiful venues. (Courtesy of Jay H. Buckley.)

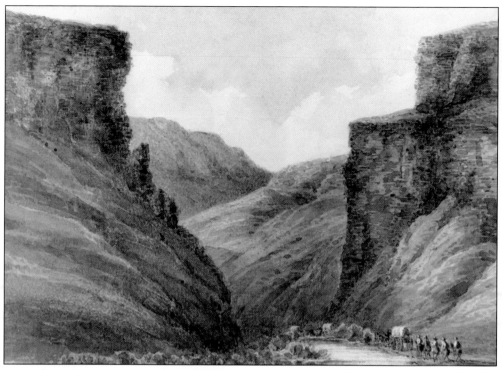

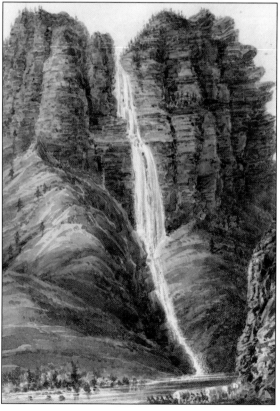

Artist H. V. A. von Beckh supplied the illustrations, and J. J. Young created the finished watercolors of these early depictions of Provo Canyon and Bridal Veil Falls. Beckh accompanied Capt. James H. Simpson of the U.S. Army Corps of Topographical Engineers in the summer of 1859, when he came to Utah to survey and construct a wagon road through the Great Basin. The military party consisted of Simpson (commander), Lts. J. L. Kirby Smith and Haldimand S. Putnam ("topog" officers), and an escort of mule-mounted infantrymen and dragoons. Completing the group were several civilians, including a geologist, naturalist, meteorologist, artist, daguerreotypist, packers, Mexican herdsmen, and American Indian guides. (Courtesy of Utah State Historical Society and the National Archives, Washington, D.C.)

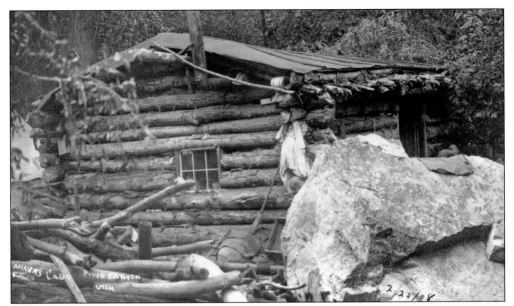

This Olson and Kafen image portrays a miner's cabin in Provo Canyon around 1902. Mining enterprises in Provo Canyon did not pan out, but miners achieved more success in nearby American Fork Canyon and Rock Canyon. (Courtesy of Western History Collection, Denver Public Library.)

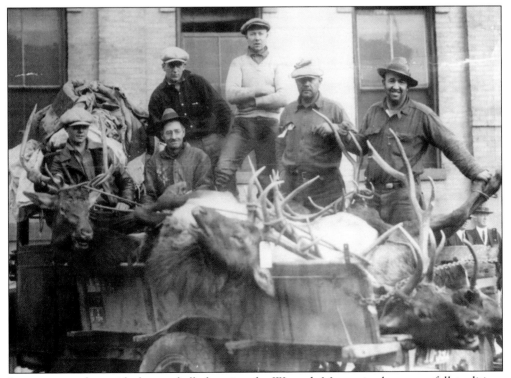

In an area profuse with deer and elk, hunting the Wasatch Mountains became a fall tradition. These six hunters proudly display the elk they bagged on their 1924 hunt. (Courtesy of Orem Heritage Museum, SCERA.)

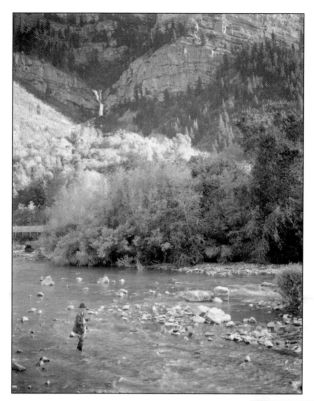

The Timpanogos or Provo River has historically teemed with fish and presently represents a premier blue ribbon trout fishery containing thousands of large brown, rainbow, and cutthroat trout. These two c. 1910 images show a fisherman near the upper falls while the second portrays James W. Shipler up to his waist in fly-fishing heaven. (At left, courtesy of George L. Beam, Western History Collection, Denver Public Library; below, courtesy of Utah State Historical Society.)

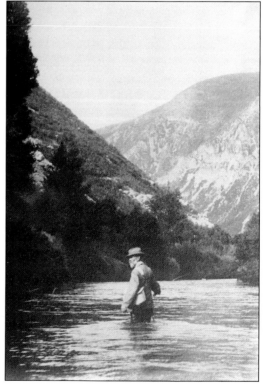

Joseph R. Murdock and the Provo Bench and Irrigation Company met in 1909, concerning the Provo Reservoir Company. The company secured the water rights to some springs and water of the Provo River and constructed reservoirs and canals to utilize the water. (Courtesy of Lon Bowen.)

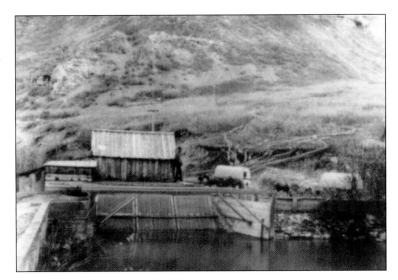

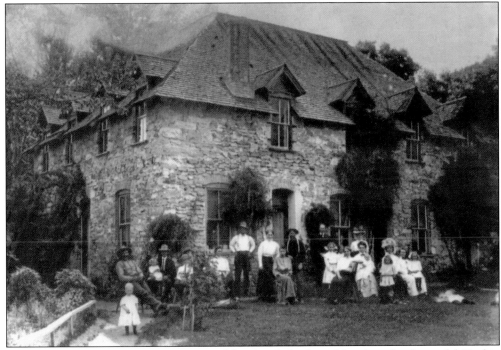

Beginning in the 1880s, Enos Carter and his family built and lived in this beautiful Gothic Revival–style home, amid the beautiful views of Provo Canyon. With all of their extra rooms, the Carters rented warm beds and a friendly hearth to the miners who worked across the river and to the men constructing the road to Heber City. In 1903, they sold their home to Hyrum and Magdalena Heiselt (pictured here with their family), who used the home as a hotel to house guests and local workers. The Heiselts attracted more affluent customers by developing trout ponds, expansive lawns, and a fountain. They maintained their picturesque canyon resort, until they sold the property to Provo in 1921. In 1927, the Town of Orem purchased nearby Heiselt Springs from Hyrum Heiselt for $10,000 to furnish water for the community's water storage tanks. (Courtesy of Orem Heritage Museum, SCERA.)

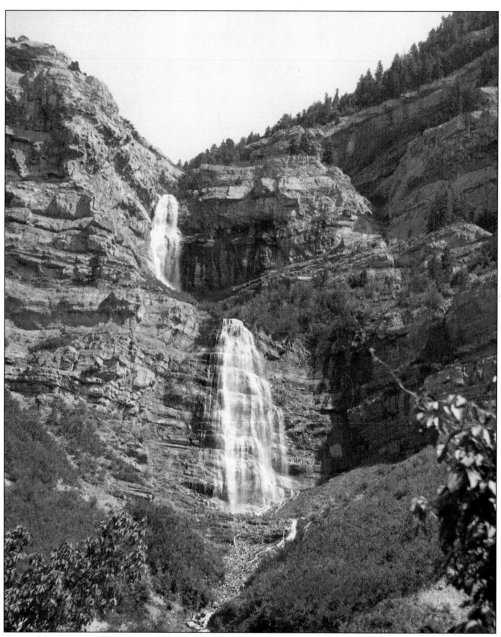
One of the breathtaking natural beauties of Provo Canyon is Bridal Veil Falls. With a 607-foot-tall double cataract falls descending off Cascade Mountain, Bridal Veil is truly one of Provo Canyon's most beautiful sites. During the summer, it attracts numerous hikers to the nearby trails, and during the winter, daring ice climbers ascend the cliff by scaling the frozen falls. (Courtesy of L. Tom Perry Special Collections, Brigham Young University.)

In 1967, the world's steepest aerial tramway angled at 45 degrees ferried up to six people at 5 miles per hour the 1,228 feet to the top of the falls to an observation deck, visitor's center, and restaurant. While the spectacular views and isolated beauty gave the business its greatest attraction, it also represented its greatest hazard. Twice the visitor's center and restaurant were severely damaged by avalanche, most recently in 1996. Following a suspicious fire, all plans to repair the restaurant were abandoned. The tram was dismantled and its lines cut in April 2008. (Courtesy of L. Tom Perry Special Collections, Brigham Young University.)

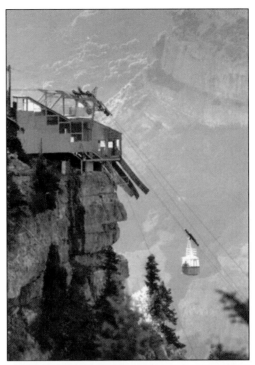

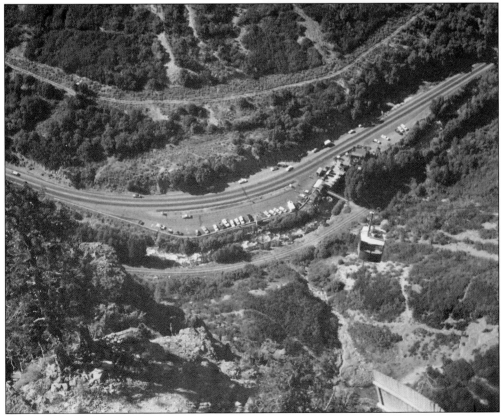

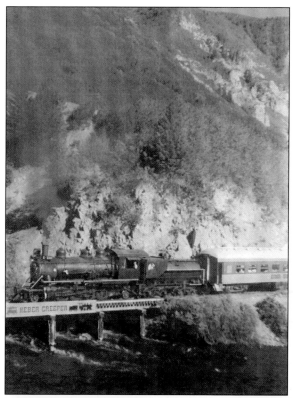

One of the best ways to get to Bridal Veil Falls was via the Heber Creeper. In 1889, the Denver and Rio Grande Western Railroad began building a branch line up Provo Canyon toward Heber City, which was completed in 1899. In 1921, the Denver and Rio Grande Western Railroad took over operation until 1967. People wanted to ride the train between Heber City and Orem/Provo, so a passenger car was added to the rear of the freight train. As the train crept up the canyon, it earned the moniker "Heber Creeper." One legend recounts the story of a newlywed couple who boarded the train in Provo and had their first child, as the train pulled into Heber. Below, Heber Valley Railroad engineer Bryan Morris assesses the track as his locomotive nears the Deer Creek Reservoir summit. (At left, courtesy of Utah State Historical Society; below, photograph by Scot Lythgoe; courtesy of Bryan Morris.)

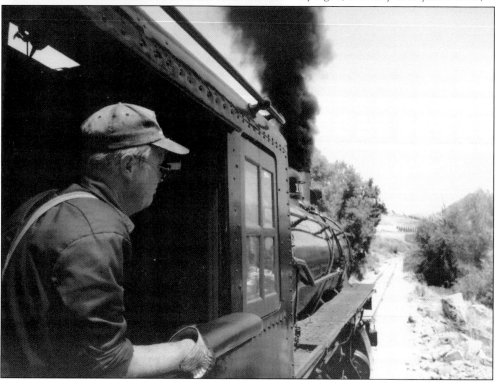

Before the Provo River was dammed in 1938 to create the Deer Creek Reservoir, the old Provo Canyon Toll Road and Rio Grande Western tracks paralleled the river. After this area was submerged by the damming of the river, the train and roads skirted the reservoir, and the water was used for culinary, irrigation, and recreational use like boating, fishing, and waterskiing. (Above, courtesy of Edward M. McLaughlin Collection; below, courtesy of L. Tom Perry Special Collections, Brigham Young University.)

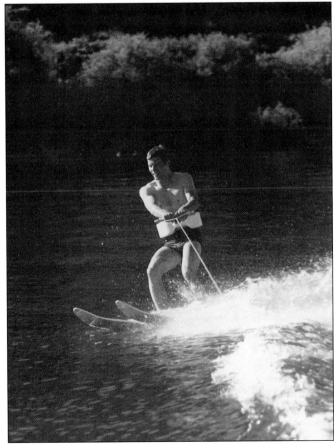

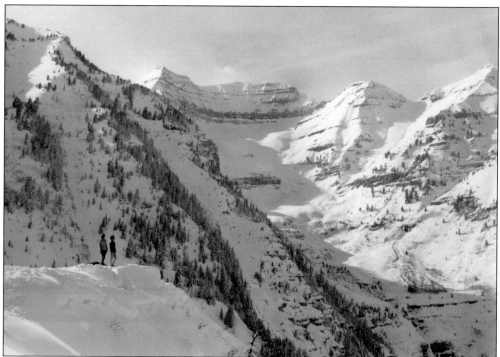

Utah is famous for its powdery snow. Mount Timpanogos (shown here looking west), with an elevation of 11,749 feet, represents the second highest mountain in Utah's Wasatch Range and has long been an attraction for Utah's hikers, campers, and skiers. In 1944, Ray and Eva Stewart cleared several slopes, purchased 1,200 feet of rope and opened a ski slope at Stewart Flat. Starting with Ray's Lift, a jerry-rigged rope tow driven by the rear wheel of an old Chevy truck, the resort grew and became known as Timp Haven in the 1950s. (Above, courtesy of Orem Public Library; below, courtesy of L. Tom Perry Special Collections, Brigham Young University.)

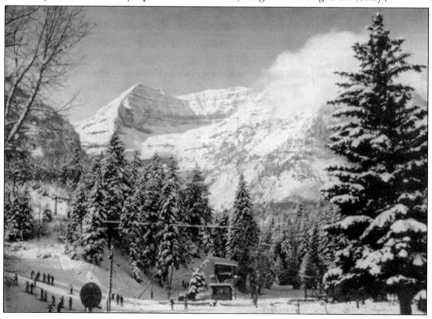

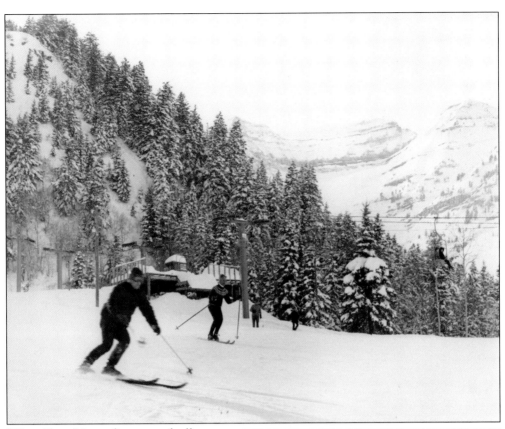

When Timp Haven first opened, all skiers had to hike nearly a mile from the parking lot to reach the base of the rope tow. Even reaching the parking lot could prove difficult after a snowfall, since the State Road Commission did not begin clearing the roads to Timp Haven until 1949. Through the years, the Stewarts and volunteers continued to improve Timp Haven. Through the summer, they cleared new runs, built jumps, and installed newer rope tows. Their continued efforts allowed the resort to continue to expand, and in the 1960s, Timp Haven traded in their rope tows for chairlifts. The Stewarts' continued to own and operate Timp Haven until 1968 when they sold the resort to actor Robert Redford, who renamed it Sundance. The Sundance Ski Resort remains a popular destination for skiers to experience Utah's greatest snow on Earth. (Above, courtesy of Orem Public Library; at right, courtesy of Utah State Historical Society.)

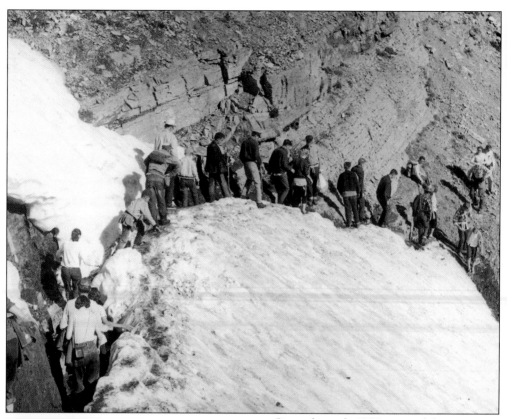

Since the early 1900s, one of the most popular summer activities involved hiking Mount Timpanogos. In July 1912, Brigham Young University physical education teacher Eugene L. Roberts wanted to encourage physical activity amongst the university students and led 22 of them up the mountain. Through the years, the annual hike drew hundreds, then thousands, of participants and many risked life, limb, and common sense for the thrill of sliding down the glacier. In 1970, the U.S. Forest Service asked the university to discontinue promoting the venture, but thousands individually still make the annual pilgrimage to ascend to the top of the mountain. (Courtesy of L. Tom Perry Special Collections, Brigham Young University.)

Eight

THINGS ARE HAPPENING IN OREM

"Things are Happening in Orem" proclaimed a monogrammed cake with Miss Orem 1969, Kerry Lynn Williamson (center), and her two attendants. The town's population had reached 25,000 and was growing quickly, as more than 300 businesses operated in town. University Parkway opened up, connecting State Street and Interstate Highway I-15 and plans were underway for the construction of the largest indoor mall in Utah to be located in Orem. (Courtesy of Orem Public Library.)

Recreation played an important role in holding Orem's community together, but that need became only greater during the dark years of the Great Depression. As families lost their savings and their investments, the community felt that they needed more to help them cope with financial difficulties. In response, community leaders gathered in 1933 and organized the Sharon's Cooperative Educational and Recreational Association (SCERA). Arthur V. Watkins, a Brigham Young University and Columbia Law School graduate, lived in Orem and started *The Voice of Sharon* newspaper (forerunner to the *Orem-Geneva Times*). Practicing law and engaging in agriculture, he also served as district judge and as a U.S. senator. An LDS Stake president, Watkins used his influence to draw community support for SCERA. At first, SCERA organized a variety of athletic competitions and held movie nights at the nearby Lincoln High School auditorium. The movie nights became very popular and allowed the SCERA finance committee (pictured below) to save funds and begin building their own auditorium. (Courtesy of Orem Heritage Museum, SCERA.)

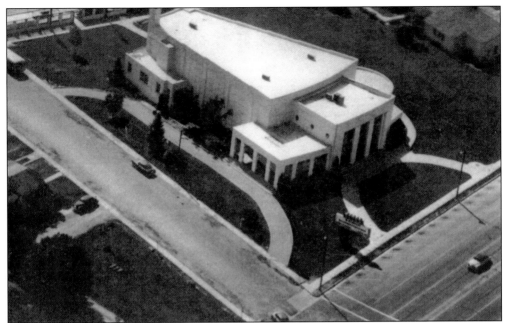

On March 23, 1940, the official ground-breaking ceremony took place before a crowd of Orem residents. After a long year of construction, financial challenges, donations, and service, the SCERA Auditorium was opened. Acting as a movie theater, performing arts center, and heritage museum, the facility remains open today. SCERA constructed a public pool at 720 South Street, which opened in the summer of 1936. The price of admission was 5¢ for children and 10¢ for adults. The profits from the admission charge, along with the movie showings, allowed SCERA to build a larger pool in 1961. Recently a new modern community pool was constructed by the City of Orem a block north of the theater. In 2009, SCERA celebrated its 75th anniversary. (Courtesy of Orem Heritage Museum, SCERA.)

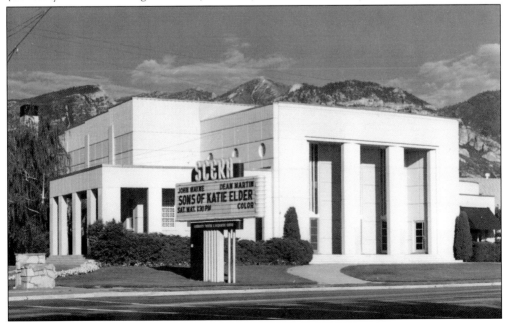

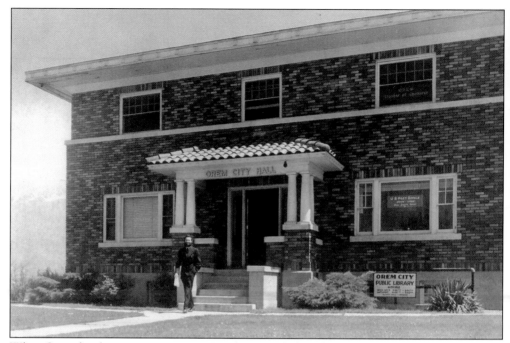

When Orem first became a town in 1919, only a specified mode of government of trustees existed to guide the community. For the first 19 years, town leaders met in homes, in orchards, or in the Snow store. In 1938, the town board purchased the 38-acre farm and home of James G. Stratton for a city hall to house the board, the library, and post office, located at 15 North and State Street. This image shows Orland Pyne standing in front of the building in 1947. The town hall became the heart of the community. Having all city services in one location made it simpler to coordinate the city's government. When the fire department was organized, it moved into the new station next door. They never had to worry about the town hall burning down or being burglarized, because the police department worked out of a windowless, remodeled bathroom in the town hall. (Above, courtesy of Orem Public Library; below, courtesy of Lon Bowen.)

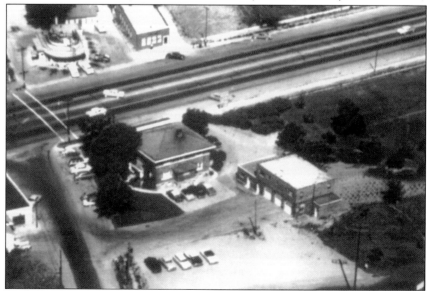

In 1950, the Orem Post Office had to move from Orem City Hall into a new building across the street to accommodate all of the mail that needed to be processed for the rapidly growing community. Pres. Harry S. Truman appointed Clyde E. Weeks Jr. as Orem postmaster on October 16, 1951. For four decades, Weeks, the former editor of the *Orem-Geneva Times*, fulfilled his duties as postmaster. He is pictured above selling 3¢ stamps to two Future Farmers of America in 1951 (the boy on the left is Ray E. Gammon, a future attorney). In 1960, Weeks received a commission from the Orem City Council to write the centennial history of Orem, which he titled *Sagebrush to Steel*. The slogan was on Orem's centennial float that traveled in the Fourth of July Parade in downtown Salt Lake City in 1961. (Courtesy of Clyde E. Weeks Jr.)

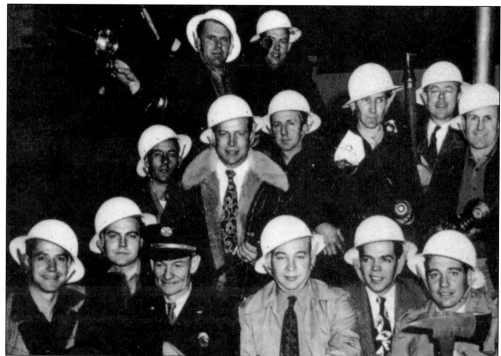

Orem's fire department began with Scott Thompson, who was named Orem's first fire chief in 1947, as Orem's first fire station was finished behind city hall. Building a fire-fighting crew with 20 volunteers, Chief Thompson trained his men in an intensive 12-week program. As the program finished, they received their first fire truck, an American-LaFrance that cost $9,000. Charter members included, from left to right, (first row) Ollie Johnson, Dixon Larson, Chief Scott Thompson, Clyde Olsen, Russell Park, Lowell Bigelow; (second row) Ted Voelker, Dick Park, Henry Campbell, Max Pederson, Lionel Fairbanks, and Howard Hall. Not pictured were Grant Young, Charles Swan, Lloyd Pyne, Rulon West, Victor Christensen, Richard Brewer, Glen Healy, and Ted Sorensen. (Courtesy of Orem Public Library.)

In 1966, Chief Thompson retired after 42 years of service. The department received a new diesel fire truck and hired three new full-time employees. The department had three trucks, seven full-time employees, and a score of volunteers. The first four salaried firefighters are pictured here in 1976. From the left to right are Arnold Long, Fred Hansen, Vernon Partridge, and Howard Jacobsen. (Courtesy of Orem Public Library.)

Orem's Police Department's first law enforcement officer was town marshal James W. Wilson, appointed in 1923. For the next 20 years, one marshal bore the responsibility for the entire city. In 1946, a formal department was created with a police chief directing three other officers. One of the greatest concerns for the new department was the regulation of traffic on State Street. The road was paved, straight, wide, and the fastest way to a popular dance hall in American Fork. The police department investigated, on average, 100 traffic accidents each month. Orem's Police Department expanded rapidly, as seen in this photograph of the 1965 police force. Later they moved in to this new facility at the Orem City Center. (Courtesy Orem Public Library.)

Lawrence J. Snow Neils A. Jacobson

James A. Loveless J. W. Gillman

Emery McKellip Russell K. Homer

From the town's incorporation in 1919, a number of wonderful leaders have served Orem. In 1919, the administration consisted of Lawrence J. Snow, president, and town board of trustees J. W. Gillman, Neils A. Jacobson, James A. Loveless, and Emery McKellip. Russell K. Homer served as the town clerk. Two of those men followed Snow in the president/mayor role: J. W. Gillman (1925 to 1931 and 1946 to 1953); Emery McKellip (1936 to 1937). Half a century later, the Orem City Council met to plan for the city's future. Those present included Stanley A. Leavitt, Ellis Rasmussen, Paul Washburn, Mayor James E. Mangum, Anne Cooper, Dixon Larson, and Harley Gillman. (At left, courtesy of Clyde E. Weeks Jr.; below, courtesy of Orem Public Library.)

Successful businesses had to keep current to make ends meet. In 1900, Jens Peter Pederson established a blacksmith shop at 400 South and State Street to serve the farmers of the Provo Bench. As the automobile became more popular and more affordable, Pederson expanded his humble blacksmithy by offering automobile repair services. Not only could he sharpen a plow and fix a cart wheel, but he could help fix up the "truck beds and trailers" that the Bench farmers were starting to use. This transition ensured that his business continued to be a success and Pederson was able to pass the shop to his son Peter, who built a new building in 1939 and then passed the shop on to his son Max. Max's Repair Shop offered tool sharpening, welding services, and overhauls for small engines. (Courtesy of Orem Heritage Museum, SCERA.)

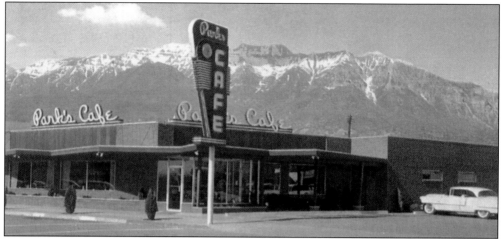

Opened in 1928 by Dean Park, Park's Café was Orem's first eating establishment. Originally it was a fruit stand and sandwich shop. After moving to a larger location at 810 North and State Street (U.S. Highway I-91 and I-89), Park's Café became a popular dining spot. This postcard described the diner as a place "where food of distinction is served in a friendly atmosphere." (Courtesy of Ellie H. Sargent.)

Orem has had its fair share of rodeos, pageants, chariot races, stock car races, motorcycle races, and ice skating, and all of these happened at the Timpanogos Bowl. Located about a half mile northwest of the city cemetery, Dean Park developed the naturally formed bowl into a stadium and erected bleacher seating for 30,000 spectators. Park had planned to sell the stadium to either the City of Orem or to Brigham Young University, but both declined. Business continued to decline until the stadium was closed. Today the land where the Timpanogos Bowl stood is a neighborhood with a short street named Bowl Street. (Courtesy of Orem Heritage Museum, SCERA.)

The Salmon Pharmacy was a cherished landmark on State Street after 1949. J. Warren Salmon had several stores through the years and knew his customers on a first-name basis. As time went on, increased pressure from national chains affected many of the longtime family-owned and operated businesses in town. Another major development was the construction of the University Mall on the corner of State Street and University Parkway in 1973. It quickly became the preeminent shopping destination in Orem and Utah Valley. (Above, courtesy of Sharon Salmon; below, courtesy of Cindy Koenig, University Mall of Orem.)

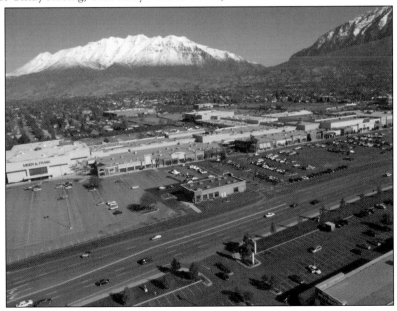

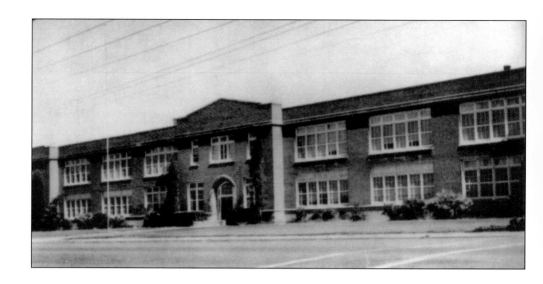

Until 1912, only elementary grades were available in Orem. The construction of a combined high school and junior high school facility at 800 South and State Street called Lincoln High School (pictured above), with Ora Cunningham as principal, extended the schooling opportunities available to students. The completion of Orem High School in 1956 enabled Lincoln to return solely to a junior high until 1975. Later the Alpine School District constructed additional high schools at Mountain View and Timpanogos. In 2009, Orem High School began a renovation project to update the facilities. Following World War II, bulging enrollments in the old Sharon School (pictured below) caused a new Sharon Elementary to be built in 1955 at 525 North and 400 East at just under $300,000. Fourteen classrooms accommodated over 400 students. Ivan Perry served as principal, and Elwood Baxter succeeded him. (Courtesy of Lon Bowen and Hollis Scott.)

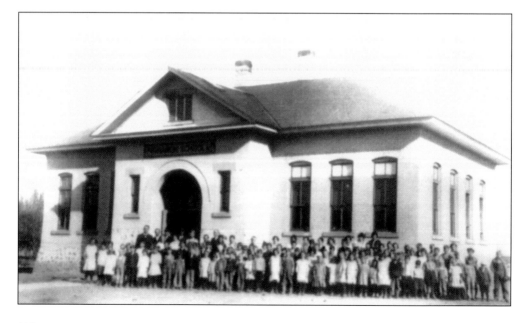

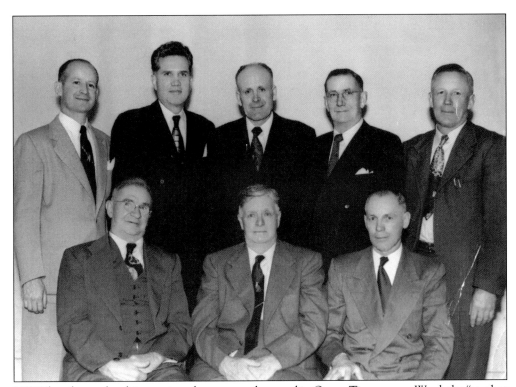

LDS Church membership continued to grow and expand in Orem. Timpanogos Ward, the "mother ward of Orem," was organized on November 8, 1885, and the renovated chapel still functions at 420 East and 800 South. The first three bishops were Peter M. Wentz, Otis Terry, and Otto J. Poulson. The picture shows the succeeding bishops before the ward's name changed to Orem Eleventh Ward on October 6, 1955. The bishops included (first row) James A. Loveless Jr., James H. Clark, Julian J. Hansen; (second row) Ray E. Hanks, Leeman B. Bennett, Philo T. Edwards, Boyd C. Davis, and Roy H. Gappmayer. Meanwhile, the Sharon Stake was the "mother stake" of Orem. Created in 1929 with Arthur V. Watkins as president, the stake divided in 1947, while Henry D. Taylor was president, to create an additional Orem Stake. On December 15, 1968, Hugh B. Brown of the LDS Church's first presidency offered the dedicatory prayer for the Sharon Stake Center building. Alma P. Burton served as Sharon Stake president with J. Murray Rawson and Ray Watters serving as his counselors. (Courtesy of Philo T. Edwards and Sterling Bylund.)

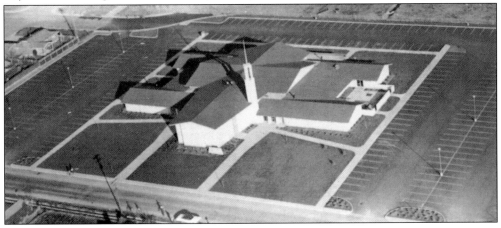

Despite renovations, additions, and moves, the old town hall quickly became too small for growing Orem. In 1967, an architect was hired to design the new city center, funding was secured, and in 1969, they broke ground. When the new city center was completed, it was an amazing improvement. The new buildings included room for city government, a new library (with 1990s renovation pictured below), and a new police and fire station. Commenting on the beauty of Orem's central location, local writer Clyde E. Weeks Jr. wrote, "Flanked by snow-capped Mount Timpanogos and landscaped with nature's most beautiful trees and shrubs, the new Orem City Center stands as a monument to the pioneers of the past and as a tribute to the pioneers of the present: pioneers who forged out a building which will serve not only as the new countenance of Orem, but as its heartbeat, as well." (Courtesy of Jay H. Buckley.)

Nine

FAMILY CITY, USA

Family life in Orem has always been highly valued. Orem residents, Gary R. and Jeanette S. Herbert, pictured here with their six children (Nathan, Kimberli, Daniel, Shannon, Heather, and Brad) and their families, have provided many years of service to Orem and Utah. Herbert served on the Utah County Commission from 1990 to 2004. When Pres. Barack Obama named Gov. Jon Huntsman Jr. as ambassador to China, Herbert (who was Utah's lieutenant governor) succeeded Huntsman as the 17th governor of the state of Utah on August 11, 2009. He is an ardent supporter of family values and personifies the values of Orem residents living in "Family City, USA." (Courtesy of Gary and Jeanette Herbert.)

Steve Densley has served as president and chief executive operator of the Provo-Orem Area Chamber of Commerce since it was organized in 1984. He is the longest serving chamber president in the state of Utah. Densley has written a bi-monthly news column for the *Daily Herald* for the past 15 years. A high school All-American in basketball and football and a Brigham Young University graduate, Densley received the Mayors Medal of Honor for his community contributions. His wife, Colleen, is the principal of Wasatch Elementary School in Provo, and they have six children and twelve grandkids. Densley loves sports, photography, and travel. (Courtesy of Steve Densley, Utah Valley Chamber of Commerce.)

From 2000 to the present, Mayor Jerry Washburn has followed through on his pledge to make Orem a better place to live and raise families and a desirable place to work and do business. A longtime resident and businessman, Washburn has seen Orem change from a quiet agricultural community to a dynamic city. His leadership has helped ensure that residents continue to enjoy an excellent quality of life and many opportunities for education, recreation, and cultural arts. (Courtesy of Steve Densley, Utah Valley Chamber of Commerce.)

Alan C. Ashton initiated the computer age in Utah Valley, the Silicon Valley of the Intermountain West. A Ph.D. graduate from the University of Utah, Ashton taught computer science at Brigham Young University, where he met graduate student Bruce Bastian. Together they developed WordPerfect in the late 1970s. The software program became the top-selling word processor for personal computers. Remuneration for his work with WordPerfect and Novell enabled Ashton and his wife, Karen, to found Thanksgiving Point in Lehi, Utah, about 15 miles from Orem. Facilities include a championship caliber golf course, a dinosaur museum, movie theater, and a 55-acre, world-class garden. Karen Ashton founded the Timpanogos Storytelling Festival, which celebrated its 20th anniversary in 2009. (Courtesy of Alan and Karen Ashton.)

LaVell Edwards played for the 1947 state championship football team at Lincoln High. He also excelled in basketball. But it was his three decades as the head football coach at Brigham Young University from 1972 to 2000 for which he is best known. Edwards transformed college football by moving it from a run-oriented to pass-oriented scheme. His quarterbacks (including Gary Scheide, Gifford Nielsen, Marc Wilson, Jim McMahon, Steve Young, Robbie Bosco, Ty Detmer, Steve Sarkisian, and Brandon Doman) threw over 11,000 passes for more than 100,000 yards and 635 touchdowns. In 1984, Edward's BYU Cougars went undefeated and won the National Championship, and Edwards was named National Coach of the Year. He retired after the 2000 season with a 258–101–3 record, a .722 winning percentage. The football stadium was renamed in his honor, and he was inducted into the College Football Hall of Fame. (Courtesy of Brigham Young University.)

One of Orem's most famous families has been the Osmonds. The talented group originally consisted of brothers Alan, Wayne, Merrill, and Jay. The quartet performed at the grand opening of the SCERA Shell outdoor amphitheater. Younger siblings Donny, Marie, and Jimmy joined them in due time. Marie's stardom increased with her number-one hit song "Paper Roses" in 1973, and her fan mail descended upon Orem. Fortunately, her brother Tom (pictured here with Marie) was an Orem postal worker. Marie then costarred with another brother in the *Donny & Marie* television show on ABC. The success of the show prompted the construction of Osmond Studios in Orem in November 1977, located at 777 North and Palisades Drive. Celebrities like Jane Fonda, Bob Hope, and Frank Sinatra all made visits to Orem, as their guests. (Above, courtesy of Clyde E. Weeks Jr.; below, courtesy of Utah State Historical Society.)

One can still drive down Orem's "Velvet Highway" past the familiar landmarks like the SCERA Theater and city center. Schools and churches dot the city, reinforcing the community's focus on education and faith. One can even find a few roadside fruit stands like Verd's to purchase fresh produce and relive Orem's agricultural past. Like their pioneer ancestors, Orem residents continue to sink their roots and consider their children as Orem's best crop. (Courtesy of Jay H. Buckley.)

BIBLIOGRAPHY

Bonner, Jeremy. "State, Church and Moral Order: The Mormon Response to the New Deal, in Orem, Utah, 1933–40." *Journal of Mormon History* 28, no. 2 (Fall 2002): 81–103.

Bowen, Lon and Reva Bowen. *Early Orem Homesteader's Profiles, 1870–1900.* Orem, UT: *Orem Geneva Times* and Orem Heritage Museum, 1996.

Cannon, Kenneth L., II. *A Very Eligible Place: Provo & Orem, An Illustrated History.* Northridge, CA: Windsor Publications, 1987.

Carter, D. Robert. *Tales from Utah Valley: Spellbinding and Sometimes Strange Selections from the Daily Herald's History Page.* 2 vols. Provo, UT: *Provo Daily Herald*, 2005 and 2007.

Chabries, April. *The Best Crop: A History of Orchard Farming in Orem, Utah.* Videocassette. Provo, UT: Brigham Young University, 2002.

Daynes, Gary and Richard I. Kimball. "'By Their Fruits Ye Shall Know Them': A Cultural History of Orchard Life in Utah Valley." *Utah Historical Quarterly* 69, no. 3 (Summer 2001): 215–31.

Dunker, Chris. *Dismantling Geneva Steel: Photographs by Chris Dunker.* Provo: Brigham Young University Museum of Art, 2008.

Holzapfel, Richard N. *History of Utah County.* Salt Lake City: Utah State Historical Society, 1999.

Larson, Gustive O. "Bulwark of the Kingdom: Utah's Iron and Steel Industry." *Utah Historical Quarterly* 31, no. 3 (Summer 1963): 248–61.

Lovin, Hugh T. "Lucien Nunn, Provo Entrepreneur, and His Hydropower Realm in Utah and Idaho." *Utah Historical Quarterly* 76, no. 2 (Spring 2008): 132–47.

Newspapers: *Deseret News; Orem-Geneva Times; Provo Herald; Utah County Journal; Utah Valley News; Voice of Sharon.*

Orem Bicentennial History Committee. *It Happened in Orem: A Bicentennial History of Orem, Utah.* Orem, UT: Orem City, 1978.

Orem Historic Preservation Advisory Commission. *Orem Historic Homes and Sites of Interest.* Orem, UT: Historic Preservation Advisory Commission, 2009.

Sorensen, Wilson W. *A Miracle in Utah Valley: The Story of Utah Technical College, 1941–1982.* Provo, UT: Utah Technical College, 1985.

Town of Vineyard. *Our Vineyard Heritage: A Wellspring of Tradition and Change, 1899–1999.* Vineyard, UT: Vineyard Press, 2000.

Weeks, Clyde E., Jr. *Sagebrush to Steel: An Orem Centennial History, 1861–1961.* Orem, UT: Orem Community Press, 1961.

LOCAL HISTORICAL ORGANIZATIONS

An ongoing effort to preserve Orem's history continues today. The Orem Public Library continues their project to digitize Orem's historic photographs. Those with images they wish to donate can contact the library at 58 North and State Street in Orem, Utah, at the north end of the city center complex (on the northeast corner of State and Center Streets). Parking is to the east of the library building and is accessed from 100 North. If you need assistance, please call (801) 229-7398.

The Orem Heritage Museum collects images and artifacts pertaining to the history of Orem. Its collection contains thousands of items, including an early agriculture and equipment exhibit. The museum, which offers free admission Tuesdays through Saturdays from 3:00 p.m. to 7:00 p.m., is part of the SCERA Center for the Arts located at 745 South and State Street, Orem, Utah, 84058-6368; phone: (801) 225-2569.

Those interested in receiving information about the National and Local Historic Registry sites in Orem should contact the Orem Historic Preservation Advisory Commission. Their contact information can be found at http://www.orem.org.

Finally, the two major universities in Utah Valley are also interested in preserving Orem images and history. The George Sutherland Archives at Utah Valley University in Orem (801-863-8821; http://www.uvu.edu/library/about/departments_archives.html) and the L. Tom Perry Special Collections of the Harold B. Lee Library at Brigham Young University in Provo (801-422-8727; http://lib.byu.edu/) offer their assistance and expertise in preserving important historical material about the region.

Discover Thousands of Local History Books Featuring Millions of Vintage Images

Arcadia Publishing, the leading local history publisher in the United States, is committed to making history accessible and meaningful through publishing books that celebrate and preserve the heritage of America's people and places.

Find more books like this at
www.arcadiapublishing.com

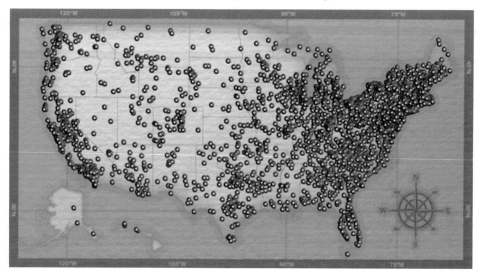

Search for your hometown history, your old stomping grounds, and even your favorite sports team.

Consistent with our mission to preserve history on a local level, this book was printed in South Carolina on American-made paper and manufactured entirely in the United States. Products carrying the accredited Forest Stewardship Council (FSC) label are printed on 100 percent FSC-certified paper.

MADE IN THE USA